Bes.
Peter
Walsh

CIVIL WAR ETCHINGS

Edwin Forbes

Edited by William Forrest Dawson

Dover Publications, Inc.
New York

Bibliographical Note

This Dover edition, first published in 1994, reproduces all 40 original etchings from the portfolio *Life Studies of the Great Army*, published by Edwin Forbes in New York, n.d. [1876]. The text is an unabridged, slightly altered republication of the text of *A Civil War Artist at the Front: Edwin Forbes' Life Studies of the Great Army*, published by Oxford University Press, New York, in 1957. This edition is published by special arrangement with Oxford University Press, 200 Madison Avenue, New York, N.Y. 10016.

DOVER *Pictorial Archive* SERIES

Library of Congress Cataloging-in-Publication Data

Forbes, Edwin, 1839–1895.
 [Life studies of the Great Army]
 Civil War etchings / Edwin Forbes ; edited by William Forrest Dawson.
 p. cm. — (Dover pictorial archive series)
 "This Dover edition, first published in 1994, reproduces all 40 original etchings from the portfolio Life studies of the Great Army, published by Edwin Forbes in New York, n.d. [1876]. The text is an unabridged, slightly altered republication of the text of A Civil War artist at the front : Edwin Forbes' Life studies of the Great Army, published by Oxford University Press, New York, in 1957"—T.p. verso.
 ISBN 0-486-28043-8
 1. Forbes, Edwin, 1839–1895. 2. United States—History—Civil War, 1861–1865—Art and the war. I. Title. II. Series.
NE2012.F67A4 1994
769.92—dc20
 94–13935
 CIP

Manufactured in the United States of America
Dover Publications, Inc., 31 East 2nd Street, Mineola, N.Y. 11501

To:

Lieutenant General James M. Gavin,

The "Stonewall" Jackson of My War.

FOREWORD

In 1861 Edwin Forbes was assigned to cover the Army of the Potomac as a staff artist for *Frank Leslie's Illustrated Newspaper*. The twenty-two-year-old artist followed the Union armies from the time Manassas was occupied in 1862 to the siege of Petersburg in 1864. Like Ernie Pyle of World War II, Forbes was not primarily interested in the great battles or in the activities of the generals. He was interested in the day-by-day existence of the Union soldiers, in the way they dressed and arranged their sleeping quarters, in the more homely, the more personal aspects of long marches and of passing weary time in camp. Although Forbes found groups more dramatic, he occasionally sketched an individual soldier, as he did Captain Joe Hutton of the 12th New York Volunteers at Culpeper, Virginia (Figure 1). Just as readers in recent years turned the pages of their newspapers to find photographs of local enlisted men, so their earlier counterparts scanned the drawings in *Leslie's* for familiar faces.

Photography was, of course, still too cumbersome a medium for taking action shots. To make a drawing was no less difficult. From time to time, however, Forbes did record a skirmish, a portion of a battle. Necessarily such sketches were quickly executed, later to be simplified and refined, as a comparison of plate 28 with the original sketch (Figure 2) will show. Some drawings were simply notes, like the long-forgotten one of 'President Lincoln reviewing the Army of the Potomac on Monday, April 5, 1863,' with slouch-hatted 'Fighting Joe' Hooker beside him (Figure 3).

From these on-the-spot drawings Forbes made the series of etchings which is reproduced here from a portfolio published without text in 1876. Entitled *Life Studies of the Great Army: A Historical Art Work in Copper Plate Etching Containing Forty Plates,* the set of prints first sold for twenty-five dollars, later for fifty dollars, and signed impressions on India paper brought as much as three hundred dollars.

From his return to his native New York City in 1865 until his death in Flatbush, Brooklyn, in 1895, Forbes continued to derive his livelihood from work based on his

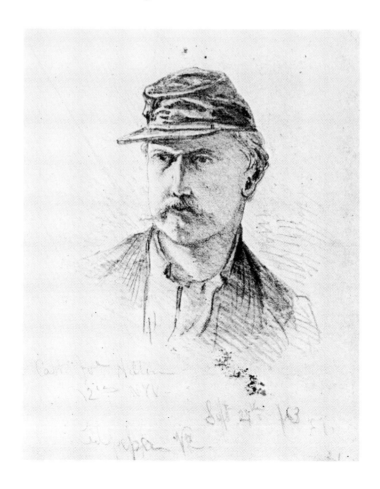

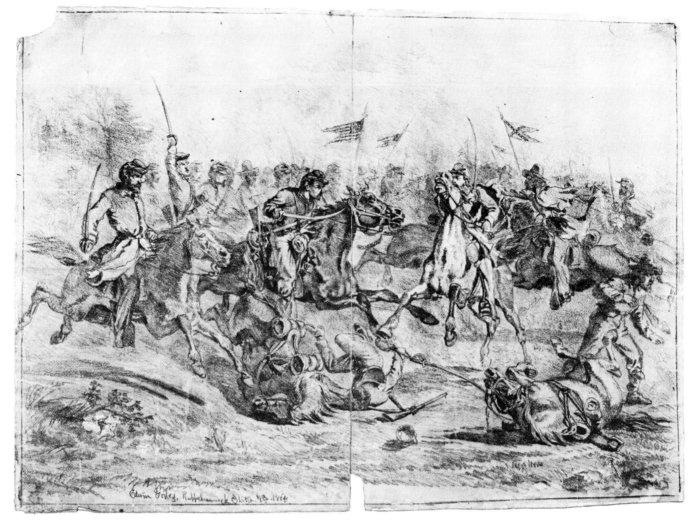

Fig. 2 *Cavalry Charge near Brandy Station, Virginia, 1864 (sketch for plate 26)*

wartime observations and experiences. In 1891 he published a second volume of Civil War drawings, *Thirty Years After: An Artist's Story of the Great War Told and Illustrated with Nearly 300 Relief-etchings after Sketches in the Field and 20 Half-tone Equestrian Portraits from Original Oil Paintings*. For this collection, which was issued in 'twenty *divisions*' at fifty cents each or bound by '*sections*' in flexible English cloth at three dollars, he made about 220 additional etchings and wrote an informal text of reminiscences to accompany them. He also included several halftone prints taken from some of his portraits of famous generals, with which he enjoyed considerable success. Presently, twelve of these portraits are in the Library of Congress. The horses painted under the generals, like those on plates 17 and 26, for example, testify to Forbes' early art school training and prewar interest in the animal genre.

Forbes did not confine himself during this period only to reworking his wartime impressions. With his usual painstaking technique he illustrated three children's histories. One of these, *General William T. Sherman, His Life and Battles*, was written by his wife, Ida B. Forbes. The other two were *Our Naval Heroes* by Josephine Pollard, and *Life and Battles of Napoleon Bonaparte* by Helen W. Pierson. Forbes suffered increasingly with a paralysis of the right hand. He had to teach himself to work with his left, and his wife's signature appears on certain of the later plates.

A member of a number of etching clubs and a frequent exhibitor during his lifetime, Edwin Forbes was best known and loved for his *Life Studies of the Great Army*. These etchings were awarded a gold medal at the Centennial Exposition in Philadelphia the year they were published, and General Sherman purchased a set of the original prints for his office in the War Department.

On March 23, 1900, a bill was introduced before Congress to appropriate $7500 for the purchase of Forbes' "historical studies and sketches of battles,

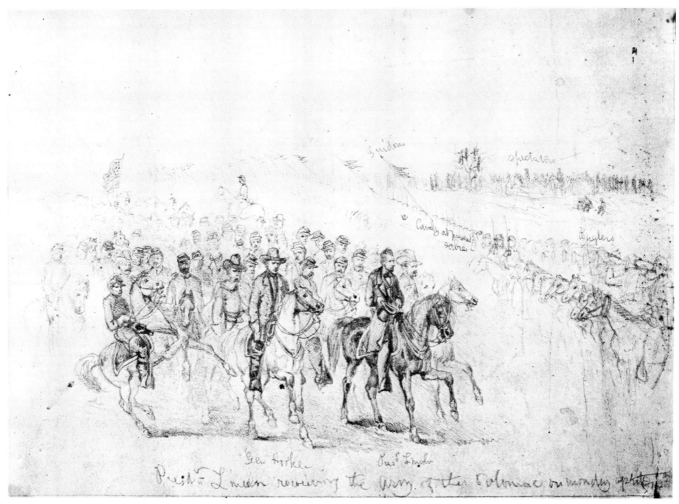

Fig. 3 *President Lincoln Reviewing the Army of the Potomac*

marches, camps, incidents, and characters of the Union armies . . . made in the field," together with the original drawings, the copper-plate, steel-faced etchings, and the artist's proofs. The collection was to be preserved by the Secretary of War and "used for reference in illustrating the history of the late civil war." Although nothing came of this proposal the Library of Congress acquired the collection through a gift of John Pierpont Morgan in 1919. The gift included about 300 drawings in portfolios as well as forty-three etched plates and the original impressions used in *Life Studies of the Great Army.*

Perhaps even more today than at the time the bill was conceived are we indebted to Edwin Forbes and the other war artists for the graphic record they have left us of our "great" war. To Forbes especially are we indebted for his vigorous and detailed drawings of the common soldiers whose daily lives are thus made more accessible to our understanding and imagination.

ACKNOWLEDGMENTS

I wish to acknowledge my special appreciation to George B. Keester, Assistant Curator of the Academy Museum at Annapolis, and to Colonel Donald B. Matheson, former Director of the Academy Museum at West Point. I should like also to thank Colonel John M. Virden and Lt. Colonel Harry C. Beaumont who have read the manuscript and made helpful suggestions, and Dwight L. Dummond, Preston and Lucy Slossen, who have helped me with historical details. I am further indebted to the Library of Congress in whose collection are the originals of the three drawings reproduced in this volume, and several of whose staff members very kindly supplied information.

Ann Arbor *William Forrest Dawson*
1957

CONTENTS

NOTE, 1994: Dawson rearranged Forbes's plates. In this Dover edition, Dawson's sequence has been retained, but for reference purposes, Forbes's original numbers are supplied in square brackets in the listing that follows.

CIVIL WAR ETCHINGS

TATTOO AND REVEILLE, THE BEGINNING AND THE END

Tattoo in Camp. In the peace of training camp, Forbes showed the regimental fife and drum corps beating out 'tattoo,' the signal for soldiers to return to their tents and make ready for bed. Half an hour after tattoo the bugler sounded 'taps,' and the moon rose on a sleeping army, snoring to the accompaniment of locusts, crickets, and tree frogs from the woods behind the camp.

Reveille on the Line of Battle. For a reveille scene Forbes drew a quite different picture. The Union Army of Major General George C. Meade is stirring from an exhausted sleep after a forced march pursuing the Confederates under General Robert E. Lee into Pennsylvania. 'As I looked about, watching the marching columns or listening to the careless laughter of the soldiers near me,' Forbes told George F. Williams, a war correspondent and lieutenant in the 146th Regiment, New York Volunteers, 'I realized that many a joyous fellow, now only intent on his hardtack and coffee, would never see another sunrise or respond again to the familiar reveille.'

It was the morning before the first day at Gettysburg.

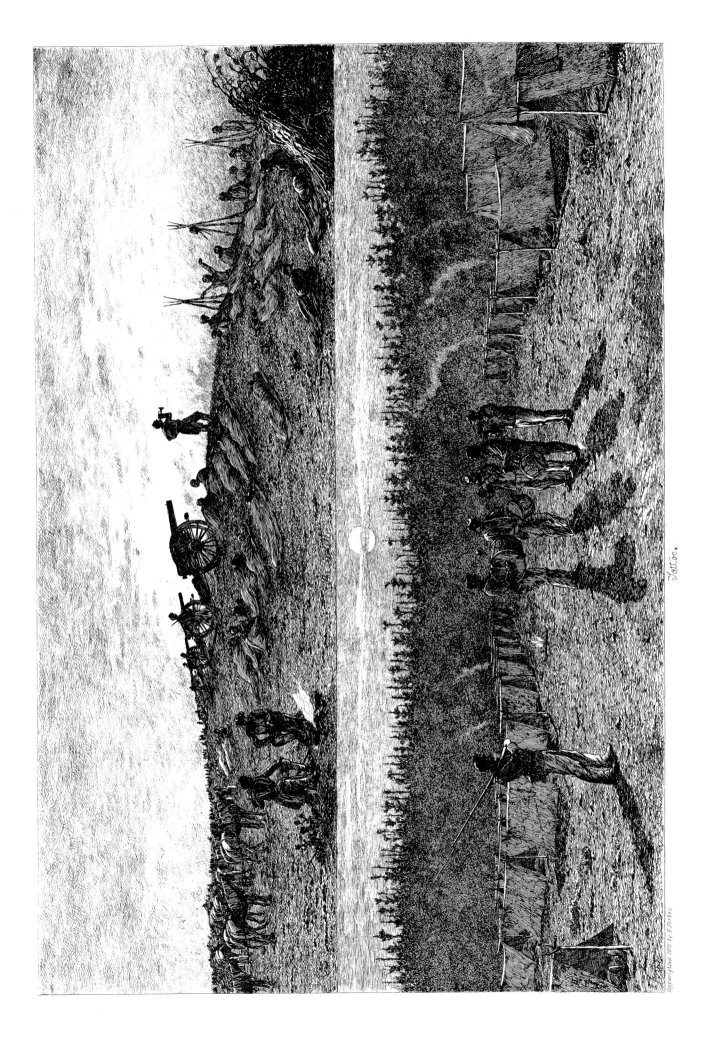

Tattoo.

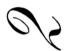

THE COMMISSARY'S QUARTERS IN WINTER CAMP

The commissary sergeant is weighing out a meat ration, which together with the inevitable hardtack constituted the dietary staple of the Army of the Potomac. Extra commissary rations might be purchased when food was plentiful, as it sometimes was in camp, and charged against the next month's pay. From the sutler's wagon the soldier might also buy luxuries, such as milk, butter, and baker's bread—when he had the money.

Hardtack was a plain flour and water biscuit, about three inches by two and one-half. The daily ration was nine or ten biscuits to a man, but quantities were left over, for hardtack was never greatly in demand. Some biscuits were so hard a man could not break them with his teeth. These had to be soaked to be eaten. If they had got wet in shipment they would contain weevils, and when a man broke his hardtack into his coffee he often found weevils squirming on top. The meat was either salt pork or salt or fresh beef. The beef was sometimes boiled, but the men preferred to get it raw and cook it themselves. The salt beef, penetrated with saltpeter, had an unappetizing rust or yellow-green color.

A tin plate doubled as frying pan and might be cleaned, if at all, with soft bread or sand; knife, fork, and spoon were cleaned by running them into the ground a few times. By attaching a wire to their dippers many men devised a pot in which to cook soup and coffee.

The Southern private stuck to his frying pan. He carried it with the handle rammed into the end of his musket. He fried pork into gravy and wiped his biscuit in it. The biscuit might also be fried or soaked in water. The Johnny Rebs ate 'slosh' or 'coosh,' which was a paste of flour or corn meal and water added to a pan half full of boiling bacon grease. Sometimes they had 'lob scouse,' which was 'slosh' stewed with broken crackers and pieces of pork. There were tales of Southern prisoners turning up their noses at Yankee food to dream of 'those solid slices of streaked lean and fat, the limpid gravy, and the brown pan of slosh inviting you to sop it up.'

There was also a saying, sometimes attributed to 'Marse Henry' Watterson, that the war was not about secession or slavery but the greater issue of hot bread versus cold.

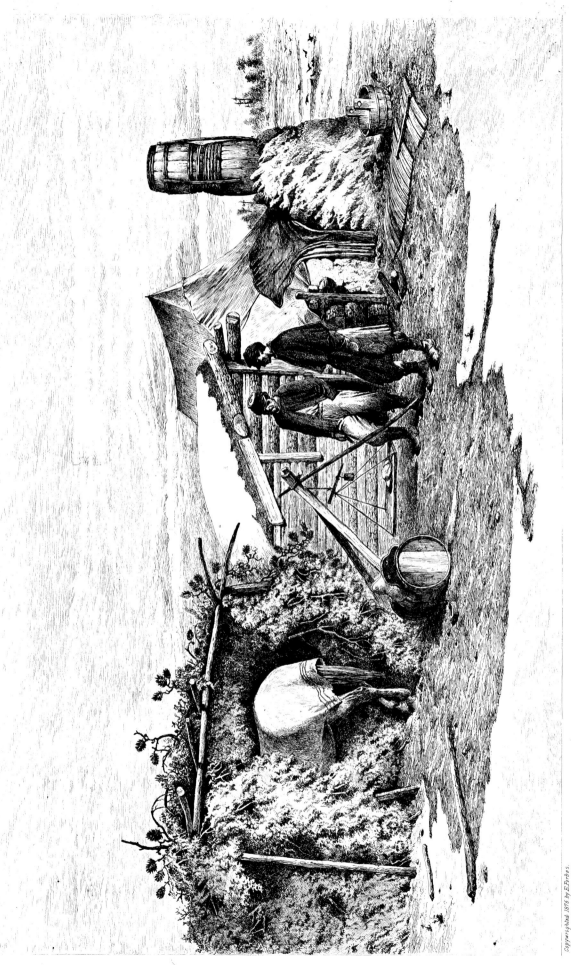

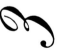

3

RETURNING FROM OUTPOST DUTY

The soldiers shown here are returning to winter camp from a week on outpost duty. In winter the Union soldier added a light blue overcoat with cape to his regular equipment. Reduced to a minimum the private soldier consisted of one man, one hat, one blue jacket, one gray flannel shirt, one pair of heavy blue-gray pants, one pair underdrawers, one pair heavy shoes, one pair gray wool socks. He carried a single shot muzzle-loading Springfield rifle with a fluted steel bayonet eighteen inches long and joined to the rifle by a neck socket which fitted over the muzzle.

Dozens of other rifles were in use: breech- and muzzle-loaders and various repeater types. They were made in Belgium, England, and France, as well as by private firms in the United States. The Government took them and reamed the barrels for a .58 caliber standard ammunition. Cartridges were paper envelopes containing powder and lead slug for one shot. Not until late in the war did metal-cased cartridges and breech-loading repeater rifles come into general use. About forty rounds of ammunition went in the cartridge box on the belt, along with the equally necessary tin cup. Most soldiers carried another sixty rounds in their pockets and knapsacks when they went into battle.

Into the knapsacks also went personal baggage, extra clothes, a rubber blanket and a woolen one. Some soldiers bore a shelter tent, with their blankets rolled on top of the haversack or slung in a horseshoe roll over one shoulder and tied at the opposite hip. Finally, their equipage was not complete without a pet. The soldiers had all sorts of pets, from red squirrels to bear cubs, from owls to mongrel dogs like the one shown tagging behind.

Units were identified by corps and division insignia on the front of their caps. In the Army of the Potomac, for example, the 2nd Corps had a cloverleaf, the 3rd a diamond, the 5th a Maltese cross, the 6th a Greek cross, the 11th a crescent, and the 12th Corps a five-pointed star. Each division within the corps had insignia of a different color. The squad here was from the Pennsylvania Bucktails, so called because they wore a deer tail pinned to their hats. Only a few hardy souls kept wearing these after their regiment's first battle. The white side of the buck's tail made an inviting target—and trophy.

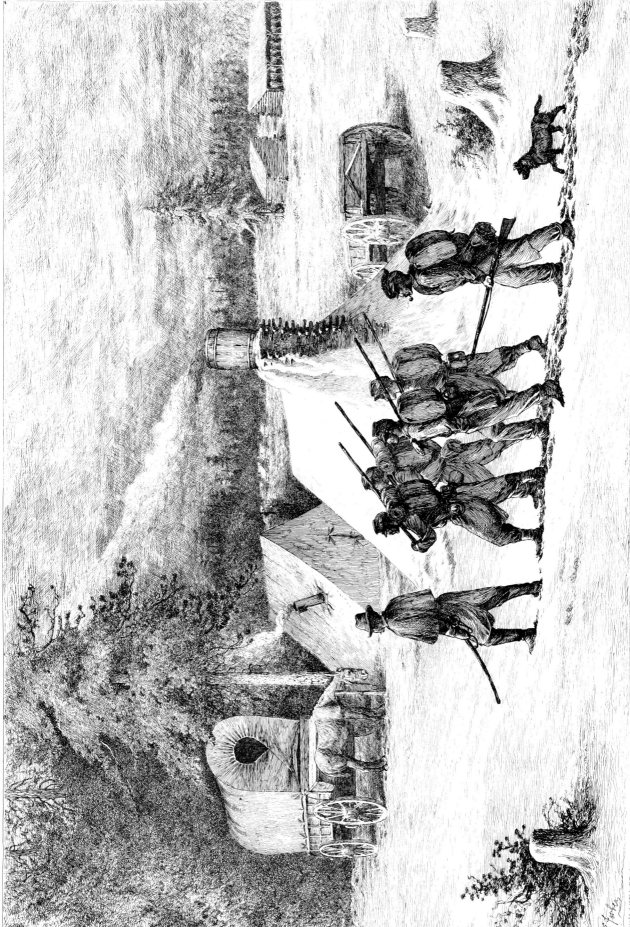

The return from Picket duty.

FALL IN FOR SOUP—COMPANY MESS

Most of the Army of the Potomac spent the winter of 1862–63 at Falmouth, Virginia. The camp was established on the heights across the Rappahannock from Fredericksburg, its extent merely suggested in this etching. The tents and stumps of the camp present as cheerless a prospect as the stew and biscuits doubtless did to the men in the soup line. The third man in this line was drawn after Walt Whitman, a company aide man whom Forbes knew well.

The mules had to be fed too. A wagon train is shown coming down the road on its way to the supply depot. In winter the problem of feeding the animals was relatively simple if the forces were connected with their base of supplies by railroad, but sometimes the hay and oats had to be hauled long distances over poor roads, inflicting a heavy toll on horses and mules. During the summer the problem was less difficult, for the animals could feed on standing grain.

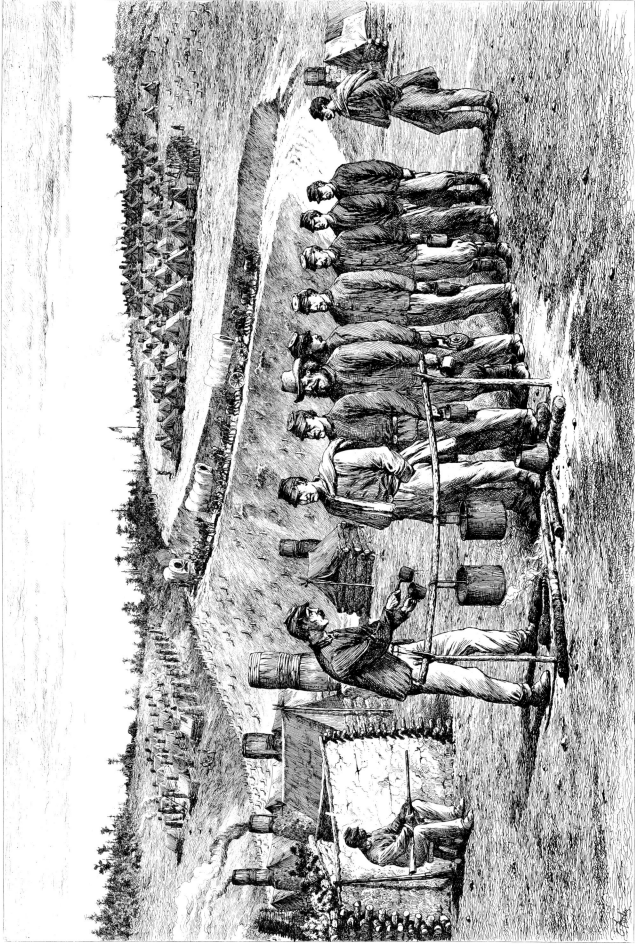

Fall in for soup.

THE SUPPLY TRAIN

Supply trains seemed to compose the greater part of the army, Forbes declared, and could be seen everywhere. They filled the roads on the march and covered miles of fields in every direction when the main body halted. In summer they lumbered through clouds of dust or showers of sticky yellow mud. They crept along over mountains and through valleys, looking like strings of white beads.

At the beginning of the war the trains were very large, carrying far more equipment than proved necessary, and a single regiment used more wagons than a whole brigade did later. When an army of 100,000 was on the march, Forbes said, the wagons if stretched in a line would have reached a distance of fifty miles. Before very long, however, the trains were broken up into more manageable and more easily defended divisions.

The wagons were heavy four-wheeled vehicles with canvas covers, bearing identification, stretched across a light frame. Those in front carried food and were laden with hardtack, salt pork, beef, coffee, and, for the mules, corn, oats, and hay. At first the wagons were drawn by teams of horses, but soon mules were found to be better. The team was harnessed with padded wooden collars, chains, and tough leather straps against the heavy wear and tear. Each team was guided by a wagoner, the most successful of whom were Negroes. The wagoner straddled the near-wheel mule and managed the team with a single line fastened to the near-lead mule's bit. The mules wore blinders to keep them from shying and balking at every roadside shadow.

At night the mules brayed and whistled and kicked, biting everything in sight. In the Army of the Potomac, the troops insisted they were cursing the commanding general as they brayed 'Jo—oo Hooker, Hooker, Hooker!'

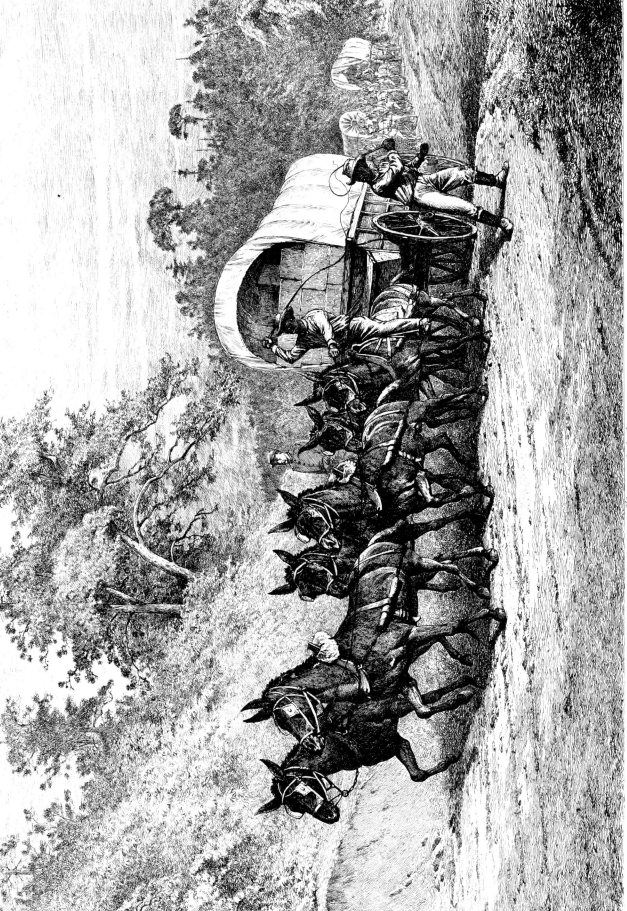

The supply train

6

HOME, SWEET HOME

Two soldiers sit in front of their hut which has a foundation of logs plastered with clay topped with their canvas tents. There were thousands of these huts, each a little different from the others. All had sod fireplaces which drew badly. Here the enterprising old codger with the homemade violin has used a plowshare to keep the smoke out of his quarters. Most soldiers used commissary barrels. Some made crackerbox doors hung on leather hinges. These tent huts were quite snug. They had to be, because between them tentmates had only two ponchos and two blankets for protection against the cold.

The front half of the shack was scooped out and the back filled in with dirt and pine boughs, forming a bed which doubled as a seat. Next to their bunks for a reading light, the men stuck candles on the ends of their bayonets. When candles ran out, they made Roman lamps by filling sardine boxes with grease and lighting a floating rag in each. Pin-up pictures from the newspapers dressed up the 'home away from home.' When the soldiers were not taking each other's money in poker games, they were trading pen knives and paperbacked novels to relieve the monotony. They hauled firewood, sometimes for more than a mile as the trees around Falmouth disappeared. They also walked guard and pulled picket duty. Most of the men agreed that life in the winter camp at Falmouth, or 'Foul Mouth' as they called it, was better than fighting or marching.

THE PICKET LINE

In the early spring of 1864, Forbes visited the Army of the Potomac's outer picket line. The line ran along a ridge of hills above Beverly Ford on the Rappahannock and commanded an extensive view of the country. He sketched the scene and later described it in his own words:

'In the foreground was a line of rude picket huts, tenanted by groups of soldiers, while within short distance men on duty were passing up and down with guns at shoulder. Across the Rapidan, about fifteen miles to the south, was a range of hills on which General Lee's army was camped, and from which with the aid of a glass faint columns of ascending smoke could be discerned. Nearer to my position were the blue crests of Thoroughfare Gap and Cedar Mountain, where Banks' division made so gallant a fight against Stonewall Jackson's superior force. Further to the left, Pony Mountain could be seen, with a log signal-station on its rocky crest. At its foot lay the sleepy old town of Culpeper Court House, and from the woods and fields around, the blue smoke drifted from Union camps there located. Less remote, near Brandy Station, could be seen the headquarters camp of General Grant, snugly ensconced in a pine grove. The Rappahannock meandered through the brown fields of the valley beneath, lost to sight here and there among groups of leafless trees on its banks. The snow-capped [sic] Blue Ridge Mountains rose in the western horizon, their azure tint suggesting the origin of their name. Scanning their summits from the south to where they faded towards Harpers Ferry, I recognized Chester Gap, through which I passed with Banks' division in the summer of '62 on the way to Cedar Mountain. Ashby's Gap, the scene of many desperate cavalry fights, was visible; also Manassas Gap, through which the railroad passes into the valley. Snicker's Gap could be discerned and far to the north could be seen indistinctly the dip at Harpers Ferry. "Dark and bloody ground" it all is; scarce a hill but has been a scene of struggle, and along its roads and paths and in deep recesses of woods terrible tragedies have been enacted. Thousands of shallow graves were scattered through this country, and thousands of human bones have lain bleaching in the sun.

'The slightest movement of any object for miles around or the faintest rustle near by, had a significance of danger to the picket guard. All day long the ground was scanned, and at night the vigilance increased, for surprises were frequent, and Union deserters or Rebel spies made their way about under cover of darkness.'

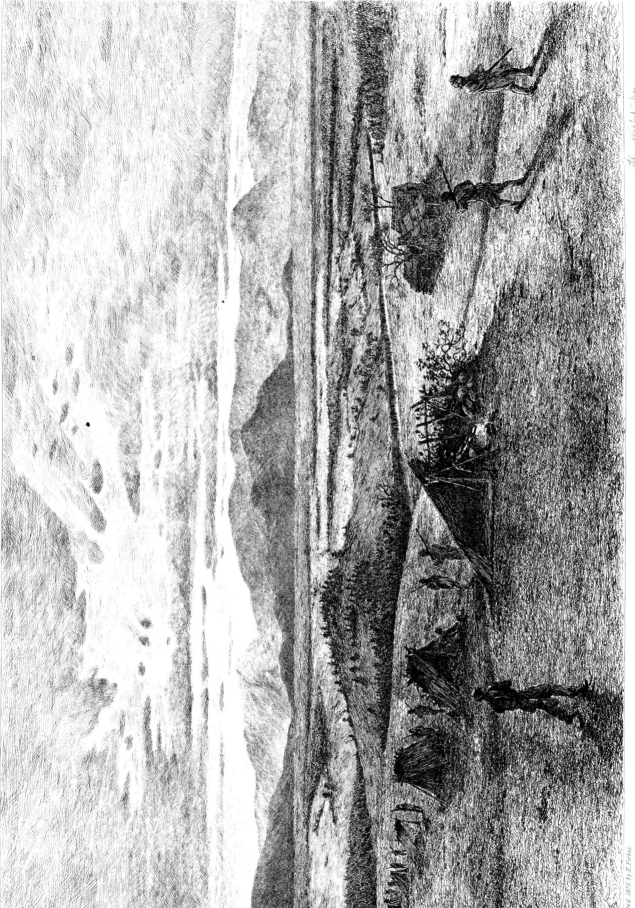

The Picket Line

Copyrighted 1876 by E. Forbes

A CHRISTMAS DINNER

To those on picket duty at the front, Christmas was like any other day, and few men took time to feel sorry for themselves. Some commands issued an extra ration of whiskey to the surprise of more than one private. 'What's this for?' he would ask, and then remember that it was Christmas Day. To judge from the blowing overcoat on the bundled-up sentry in the background, Christmas Day, 1863, was unusually cold and windy. The man cooking dinner in the foreground has been relieved from his two-hour guard tour. After warming himself inside and out, he would have crawled into his shelter to sleep. This may not look luxurious, but almost any soldier in the Union Army preferred picket duty to any other. It gave him a chance to get away from the camp and to be himself. On the picket line officers and men forgot rank. They talked and got to know each other as human beings. It was important work too, and would often restore ambition lost in the aimless life of winter camp.

A good picket, like the one here, always hung his rifle up-side down to keep the barrel clean. The fence rail shelter is typical. Each time the Yankee soldiers stopped at night, there was a rush for fence rails. The rails were used under the bed roll to keep the soldier off the damp ground. They were used over the lean-to as supports and ribs on which to lace the pine boughs that kept out the cold. They were also used for firewood, for corduroy roads, for tent braces, for cabin timbers, and as fulcrums to hoist wagons out of the mud. Next to his rifle and his shovel, fence rails were the Union soldier's best friend. Had the Rebel forces been willing to burn all their rail fences at the beginning of the war, Yankee foot soldiers might have grown too discouraged ever to have taken Richmond—or they might have been less comfortable and taken it sooner.

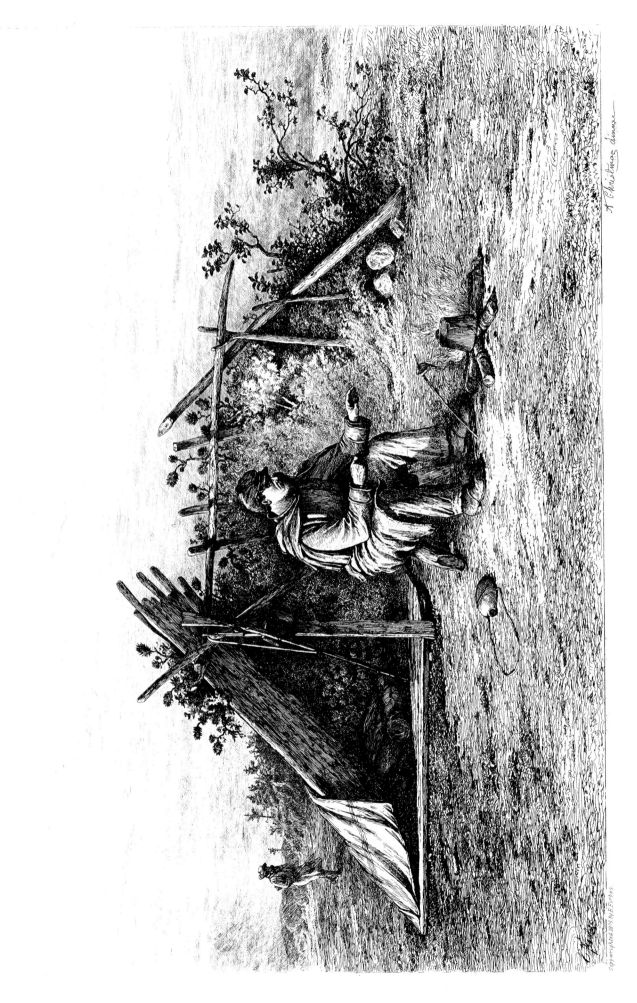

A Christmas Dinner—

9

MARCHING IN THE RAIN

Stuck in the Mud. After the defeat at Fredericksburg in December, 1862, the Army of the Potomac under Major General Ambrose E. Burnside lay camped on the heights of Falmouth. Confronting them from the opposite side of the river were the Confederate forces under General Robert E. Lee. 'Why doesn't our army move?' 'Push the Rebs out of there and on to Richmond,' the Northern press insisted. Burnside favored moving, but his subordinates argued caution. At last from Washington the command came to break camp. Huts were dismantled, tents struck, excess baggage thrown away, and a vigorous cheerful army marched out toward the fords. It was a warm sunny day when they left camp, but by evening it had started to rain.

When the men resumed their march in the morning, the rain was torrential. Passable roads had become swamps overnight. Foot soldiers, mules, and horses fell through the broken logs in the corduroy roads and wallowed belly-deep in the mud. The roads were clogged with vehicles, so that marching columns, artillery, and wagon trains had to go cross country. The horses plunged onward, throwing up yellow mud which stuck to everything it showered upon. The heavy wagon trains, churned through the mud and water, their wheels deep in the mire. The mules, straining under their loads, sank and died.

By mid-day order and discipline were gone. A chaplain reported that an officer shot a man for backtalk and no one even looked around. When the exhausted men staggered into camp two days later, they found soaked and naked tent frames. Within a week order was restored. Tents were patched and old huts reroofed with canvas. Blue smoke rose from the mud chimneys. The only sign of the Confederates were those that read 'Burnside's Army Stuck in the Mud,' which the Rebels had put up along the route of march.

A Flank March across Country during a Thunderstorm. 'The men marched steadily through the downpour, protecting themselves as best they could. Some covered themselves with rubber ponchos, and often one would share his with a less fortunate comrade by stretching the rubber covering across two short poles and marching underneath the shelter of this improvised umbrella. Some would cover themselves with blankets, but these, not being waterproof, gave only partial protection. The column presented a soaked and bedraggled appearance.' Thus, Forbes, with his etching before him, recalled sitting on his horse and watching the troops go by. 'The formation was in open order, each man marching at his own ease and carrying his gun as he could. At times the column would take to the fields, and throwing down the fences would make a wide-beaten road, brushing aside the corn and trampling the wheat and rye into a miry mass. Back and forth on the flank of the column staff-officers were hurrying to urge the men into rapid and continuous movement so that the line should not be broken and distance lost.'

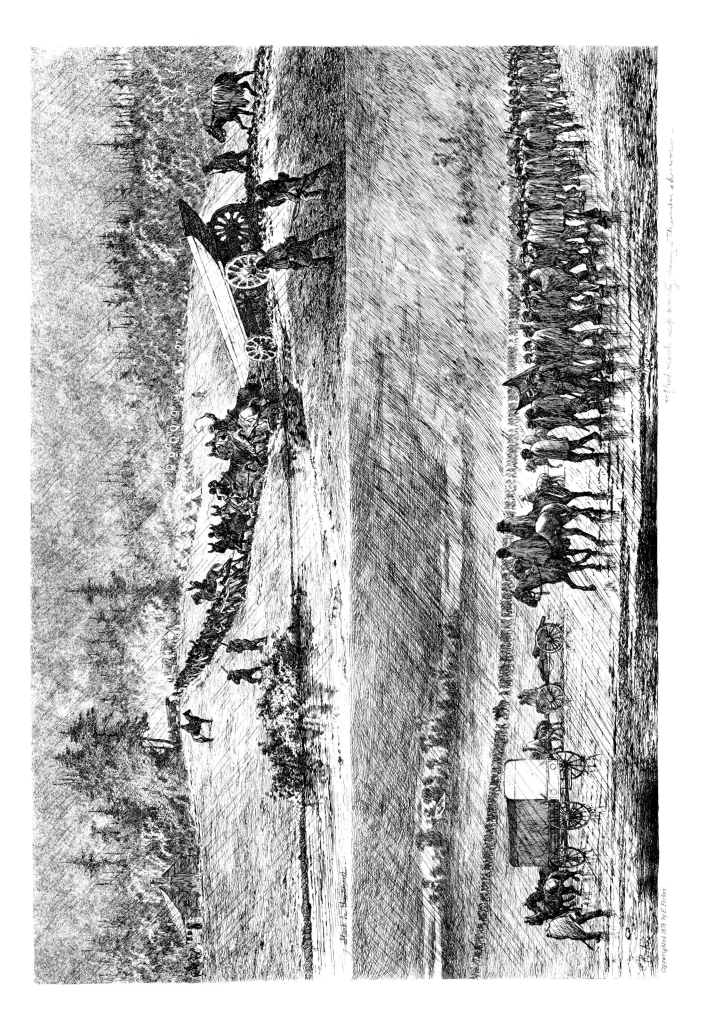

Stuck in the Hummock

OFFICERS' WINTER QUARTERS

The afternoon dress parade was a regular occurrence during garrison duty. Spit and polish generals like George B. McClellan and Joseph Hooker encouraged the practice as a regular part of training. After the dress parade, officers of each regiment, as Forbes shows here, relaxed in their command posts waiting for dinner. In the doorway the corporal of the guard reports to the officer of the day that his guard mount is posted. Presently, a Negro waiter may serve dinner. Field grade officers often had a 'bat boy' and a horse, regardless of their branch of service. These were privileges of rank to be

sure, but the military discipline and respect that rank obtains in the regular army were not so readily observed by the state militia or the volunteers of the 'Grand Army of the Republic.'

When Irwin McDowell marched his militia forward to attack P. G. T. Beauregard at Manassas Junction, or First Bull Run, the men swarmed over the adjacent country, picking berries and plundering orchards. They lost the battle and then reeled back from Bull Run, a tumultuous mob of fugitives. They straggled into Washington and refused to go back to camp. Orders to their way of thinking were not commands, but requests to be complied with if they felt like it. The company commander was hailed as 'Cap' and the First Sergeant as 'Orderly,' since he got his stripes by passing down the 'Cap's' ideas. It took long hard weeks to convince the militia that their old cronies, 'Squire,' 'Jedge,' and 'Silas,' should be saluted and addressed as Lieutenant, Captain, and Sergeant. In some instances it took court-martial convictions, the stripping of regimental colors, and dismissal of many self-appointed officers before proper military discipline was established.

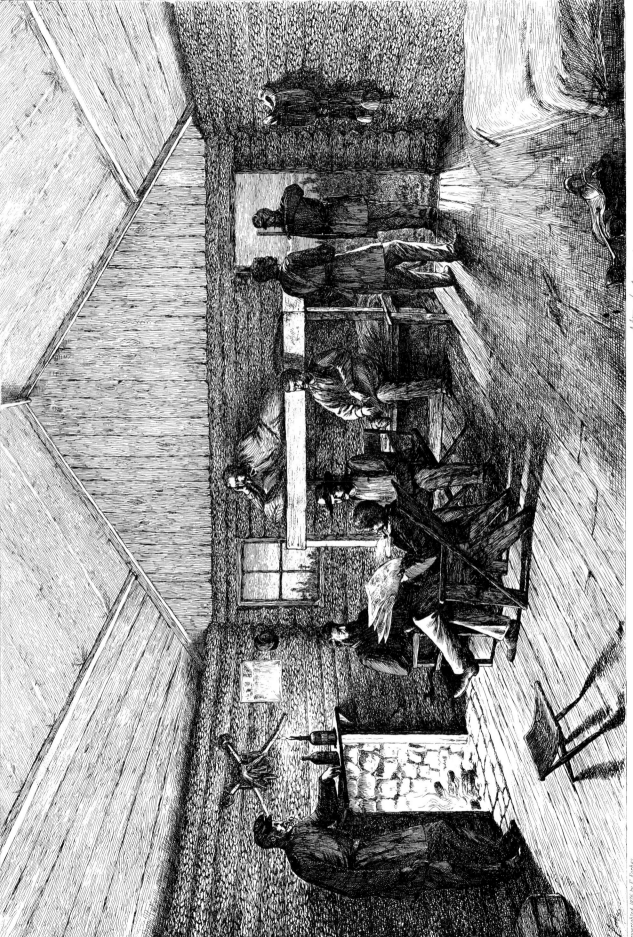

Copyrighted 1895 by E Forbes

After dress parade.

GOING INTO CAMP AT NIGHT

On the left a Zouave guard of the 38th New York Volunteer Regiment stands guard, as the never-ending column marches wearily, four abreast, into the distance where they will set up camp. There were no tents on these battle marches. Each man cooked his own food, then rolled in his single blanket to sleep. Following age-old army logic, the last weary unit into position long after dark was the first to lead off in the morning.

At one stage of the war there were more than a million soldiers in Virginia. A farmer whose son was an officer in the Army of the Potomac visited him in 1863. 'Sakes alive!' he said, 'I expected to find yer hull army on a farm of 150 acres; but I've rod ten mile on the cars, and as fur as I could see on both sides was camps! camps! camps! and I guess I know now what an army is!'

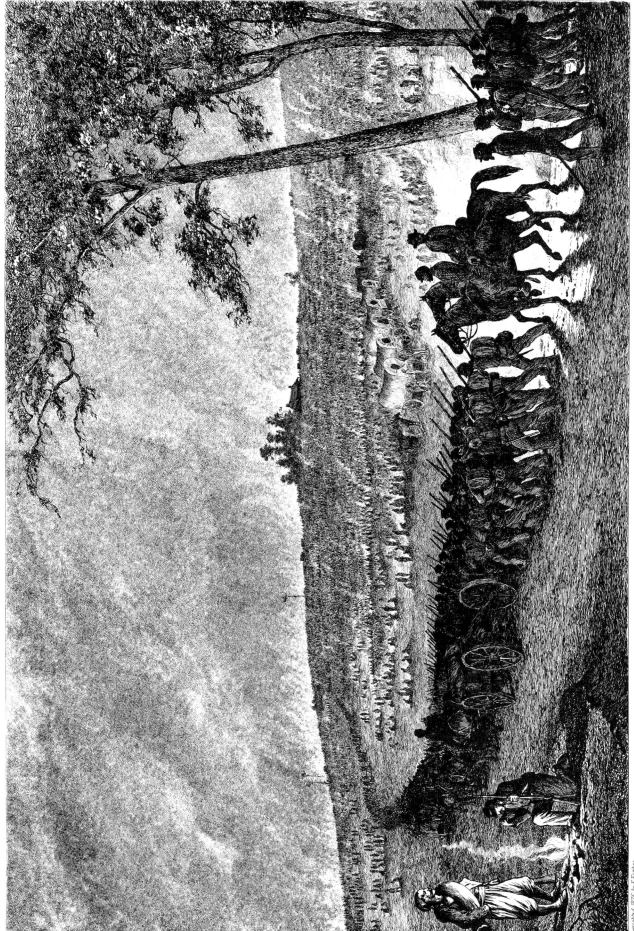

'BUMMERS': THEY'RE JOHNNIES AS SURE AS YOU'RE BORN, BOYS!

'Bummers' were the men in each unit detailed to forage for food, although the term was also applied to nurses, surgeons, and cooks. Its origin is uncertain, but it came into general use at the time of Sherman's March to the Sea. In most units the foraging was surreptitious, but Sherman organized it on a grand scale. His army traveled with a minimum of supply trains, and these were filled largely with ammunition. Every ten days the commissary issued a three-day ration of hardtack and bacon, sugar, salt, and coffee. The 'bummers' had to make up the difference, as there were no civil authorities to respond to a requisition.

Once out of camp, the bummers whether official or unofficial, would descend upon a farm and ransack its buildings, ripping open mattresses and turning wardrobes upside down as well as confiscating food and cooking utensils. One soldier borrowed a frying pan from a housewife and then asked her for a piece of meat to fry in it. One general told an indignant woman who complained of losing chickens, 'Madam, we are going to put down the rebellion if it takes every chicken in Tennessee.'

The bummers served, in a sense, as an advance guard, moving freely as they did through the land ahead of and on either side of the marching column. They had to be highly skilled and courageous; their biggest danger lay in being bushwhacked by Confederate troops. The group Forbes pictures here on horse and mule is a squad from the 21st Infantry Regiment. Huddled in the road, they are anxiously watching a distant column to see whether it is Yankee or Rebel.

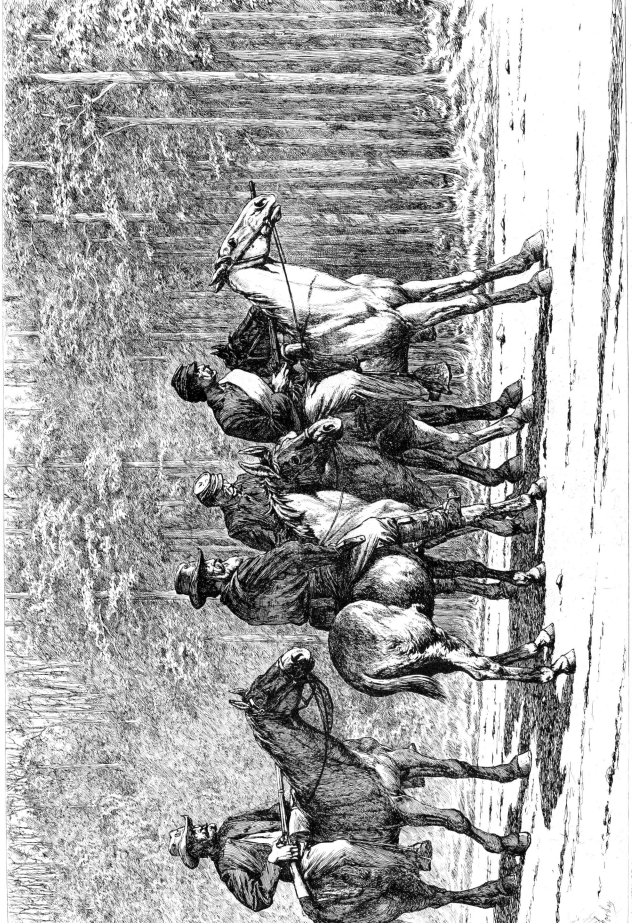

"Prisoners". "Thyer Johnnies as sure as you're born, boys!"

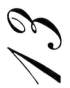

WINTER CAMP

In winter camp no two huts were exactly alike and no one hut ever looked the same way twice. The men continually scoured the land for building materials, traded for new furnishings, and dreamed up ways to make their quarters larger, warmer, and more comfortable. Good chimneys to draw off the smoke were the biggest problem, but seeing the Rebel solution in their abandoned camp helped the less experienced Yankees in their first Virginia winter. Generally, chimneys were built of small green logs chinked with clay and lined inside with sod. When the men could get them, they put commissary barrels on top of the chimney to give a longer draft. Some chimneys had a whole series of barrels stacked on a clay-baked fireplace.

A Wagoner's Shanty. Usually the most elaborate enlisted men's quarters belonged to the wagoners, many of whom had been tradesmen before entering the service. Wagoners were an undisciplined lot who enjoyed the freedom their occupation permitted. The land 'merchant marine,' they did pretty much as they pleased and had none of the clothing and housing problems of the line soldiers. They could use their supply wagons to carry window-sashes and furniture stolen from abandoned houses which they passed. There was no glory in the wagoners' dirty job, but they managed to have every available comfort.

A Picket Hut. At the opposite extreme to the wagoners' elaborate shanties were the picket huts, temporary quarters for the infantry line units on outpost duty. These were pine-bough lean-tos thrown together hastily and without the air of permanence felt back in the main part of winter camp.

Mud Huts. Architecture varied from camp to camp, from unit to unit. Whole cabins were built, when someone knew how, or transplanted along with any lumber and straw found near camp. One good carpenter in a company could perform miracles. In many places adobe huts and underground prairie sod houses with mud-plastered walls were built instead of log cabins. Cracker-box furniture and sod insulation were common.

A deserted Picket Post.

A Wagoner's Shanty.

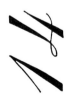

THE PONTOON BRIDGES

Early in the war McClellan's engineers built a pontoon bridge on inflated India rubber bags. Dignitaries came down from Washington to see the test. A brigade of cavalry, glorious with jingling sabers and fluttering guidons, rode down the approach and out onto the floating bridge, led by a mounted band playing 'The Mocking Bird.' It had gone but a short way out on the river when the weight and motion of the horses started the bridge swaying from side to side. The music suddenly ceased as the musicians awkwardly dismounted and stood motionless until the bridge stopped swaying. Men and horses cautiously tiptoed off the bridge, accompanied by peals of laughter from the assembled crowd.

Canvas boats with folding wooden frames were also tried, but they took too long to assemble. Heavy wooden barges, although difficult to transport, remained the accepted pontoons for army bridge work. These pontoon bridges were very like those used today. The assembling of the bridges was not less difficult than the transport of the barges. The boats brought to the water's edge, usually under cover of darkness, were slowly moved out into the river, the shower of bullets increasing as the bridge approached the opposite shore. One of the bloodiest crossings was that of the Rappahannock at Fredericksburg, which Forbes shows in progress here. A battle is smoking in the distance as the troops cross the upper bridge and prepare for the charge on the heights beyond the city. Wagons, full of ammunition, cross the lower span and wind their way through protecting valleys. A pontoon crossing, with tramping troops, rumbling guns, and creaking wagons on the plank floor of the frail, swaying structures, was a nerve-tingling prelude to the battle ahead.

The Pontoon Bridge

Copyrighted 1878 by E. Forbes

15

THE HALT OF THE LINE OF BATTLE

With Confederate dead strewn over the battlefield before them, the blue line stopped its advance to re-form and dress up. Reinforcements were coming up from the rear to fill up the lines against another charge or to move into position for a counterattack. The troops could not stand still long because Confederate shells were bursting above the Union skirmish line and bracketing in for a kill. Many a half-spent bullet or grape shot was stopped by the horseshoe blanket roll slung over a soldier's shoulder and covering part of his chest.

Like every army before or since, the Union Army could not decide whether the mounted field officers should prod on the men from behind or lead them into battle from the front, hopping they would follow. Whichever course they chose, casualties among both officers and men were tremendous.

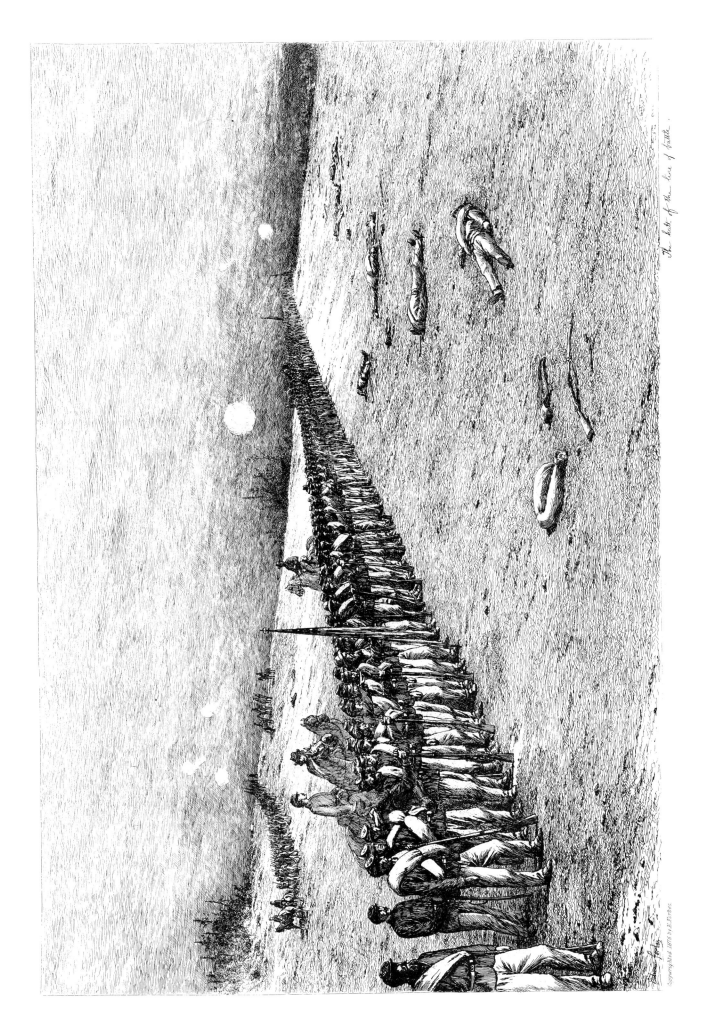

Copyrighted 1876 by E. Forbes

The brunt of the line of battle.

16

'COFFEE COOLERS'

A coffee cooler had one aim in life. He did not want to be a dead hero. He would avoid this honor by any device fair or foul. A few men in every marching column could be relied upon to disappear whenever a battle was in progress. They were to be found with their regiments only when rations were to be served at a safe distance from the enemy. In the confusion of a maneuver they would slip away to find a safe place where they could enjoy their coffee and wait out the battle in comparative comfort. When they were missed, the coffee coolers had a story about getting separated from their own regiment and fighting with another. The men here huddle around the coffee pot while their regiment marches over the hill in the distance.

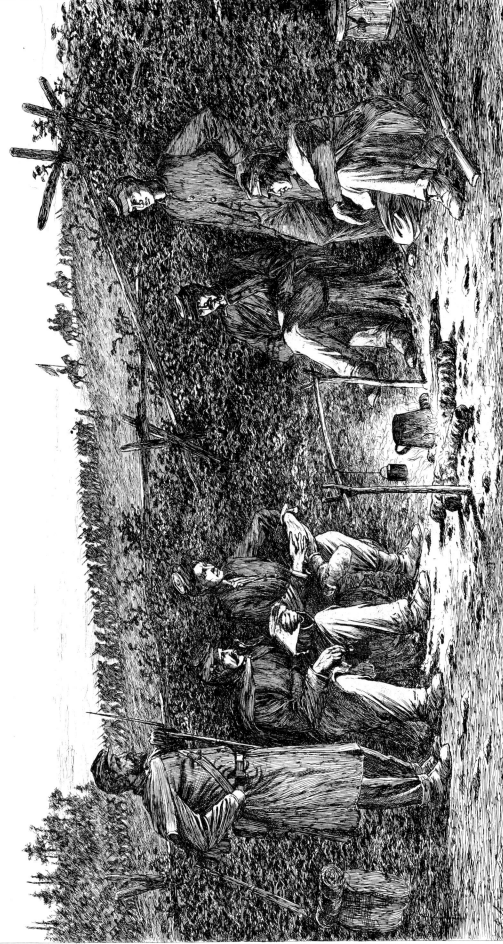

"Coffee Coolers"

iment from the volunteer firemen of New York City. The uniform of these Zouave regiments was so comfortable that other regiments later adopted it. Artists too were delighted by the bright red fez, the light blue shirt with its moire antique facings, the dark blue jacket embroidered with orange and red, and the loose red trousers.

These regiments, moreover, were proud of their reputation for military excellence and maintained the famous Zouave discipline rigorously, even after the death of their commander. Nor did the New York 11th forget its training in combatting their old New York enemy. They saved the famous Willard Hotel in Washington from burning to the ground and put out a tremendous fire in the adjoining liquor store as well. Here, however, they disobeyed their late commander's injunction against drinking, swearing, and smoking, and performed an effective salvage operation. In the drawing, Forbes shows the Zouaves' further resourcefulness in providing more solid refreshment. One enterprising man has a cabbage stuck on his bayonet, another a chicken hung on his rifle.

Newspapers for the Army. 'Dashing along at hunter's speed with rolls of newspapers thrown over the saddles, the horses galloping under their whips, every rider,' as Edwin Forbes saw them, 'desperately determined to keep his lead and secure the first sales.' City newspapers vied to see who could get early editions to the hometown troops first. Since each big city had several regiments recruited from and identified with it, the competition between papers was keen. The newsboys here are from the *World* and the *Herald*, dashing past the road guards, each hoping to scoop the others.

A THIRSTY AND A NEWS-HUNGRY ARMY

A Thirsty Crowd at the Old Spring House. 'People at home don't value water,' said a thirteen-year-old fifer in a letter home. 'If you saw the men out here with cracked and blackened lips and tongues swollen with the terrible thirst, you would value it more.'

The regiment shown here was the New York 44th, known as 'Ellsworth's Avengers,' because they were organized shortly after the spirited Colonel Ellsworth was killed in an attempt to remove a Confederate flag from a hotel at Alexandria, Virginia. Some years before the war Elmer Ephraim Ellsworth had reorganized the National Guard Cadets in Chicago and drilled them according to French Zouave manual used in the Crimean War. Spurred by his success he later recruited a reg-

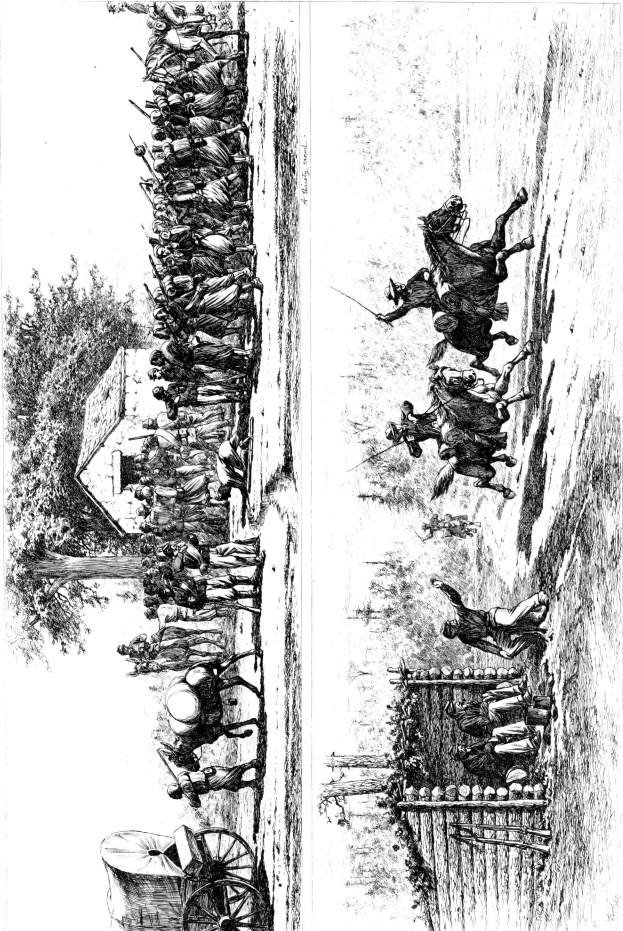

A thirsty crowd

Newspapers for the Army throw for camp

Copyrighted 1876 by E. Forbes

'It seemed scarcely possible,' Forbes reminisced, 'that within so short a distance were men who at a moment's notice might engage in deadly conflict and yet the men who do such deadly work are free from actual malice.'

The Old Saw Mill. Two Conestoga wagons have drawn into the shade near an old mill. Here the soldiers may have found lumber or even abandoned tools, but two of the party, equipped with fishing rod, sought a different sort of prize.

Waiting for Something to Turn Up. At intervals during a great battle, there will be a period of calm. Along the lines at the extreme front an occasional skirmish shot may be heard or an unexpected shell whizz through the air, cutting off limbs of trees and sending up a cloud of dust on striking ground. The men hardly look up. Only the guards, like the one standing in the high oak tree, are constantly on the alert. This is easy for a man trying not to fall out of a tree. To stay awake on sentry duty is more difficult. It was especially difficult, during the early days of the war, for farm boys who were accustomed to going to bed early.

Private William Scott, a Green Mountain boy of the Vermont brigade, was one who fell asleep on post near the Virginia slopes of the Chain Bridge outside Washington. Sentenced to death by a court-martial he was fortunate enough to be pardoned. In fact, President Lincoln, who had received a visit from several friends of Scott's, rather undisciplined volunteers, came personally to talk to the boy. Some 260 Union soldiers not so fortunate were executed through courts-martial during the war.

WAITING FOR SOMETHING TO TURN UP

On Picket at the River Bank. Between the Northern and Southern troops the Rappahannock River in Virginia formed a no man's land. In the summer of 1863, Forbes sketched this lone sentry during a visit to the Union picket lines along the river. He noticed smoke from a campfire in an orchard across the stream and was told by the nonchalant picket that it was the gray coats, but he need not worry because by tacit consent both sides had agreed not to fire on pickets. Although Forbes was still apprehensive, he agreed to walk along the stream as guest of the officer in command.

They saw a Confederate fishing for perch, and Forbes' host shouted over, 'Did you catch any?' He received the answer, 'No!' There followed a friendly banter about the Yankee fish not biting on 'Secesh' worms and Confederate fish not caring to bite in water polluted by the damnyankees. At one place along the bank, Forbes encountered a Yankee tenor singing as he cooked his supper. Across the river a Confederate quartet joined the chorus.

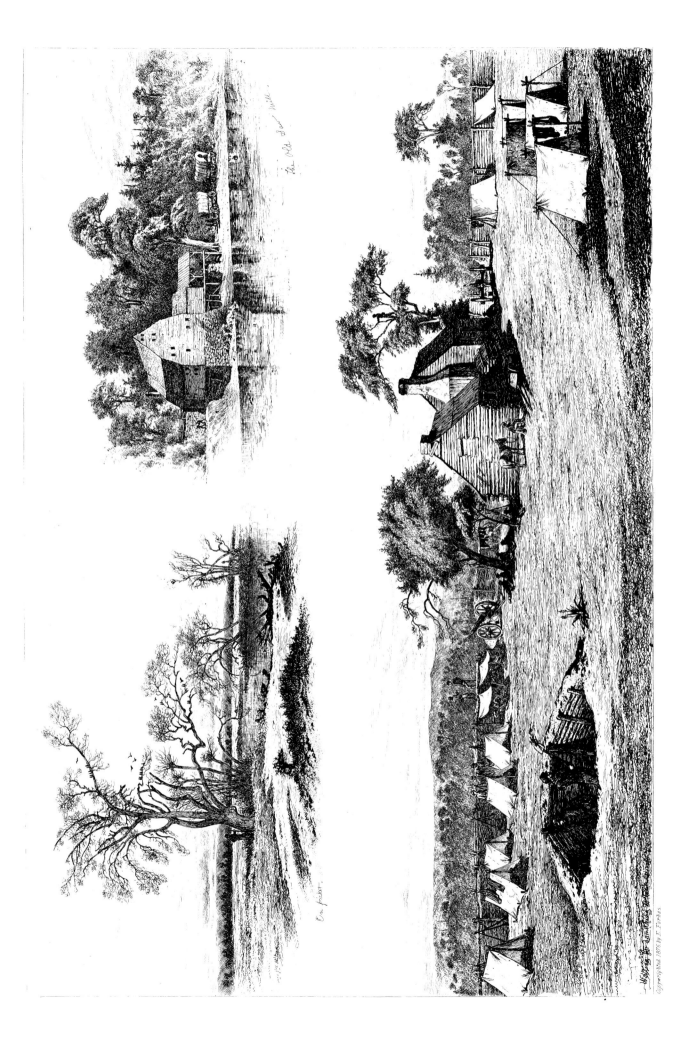

The Old Saw Mill

On picket

Sketched by Edwin Forbes
Copyrighted 1876 by E. Forbes

19

THE LULL IN THE FIGHT

The troops show only casual interest in the squad of Confederate prisoners being brought in through the lines. This took place well into the third year of the war when the Confederates had lost all uniformity in dress. They wore captured Yankee uniforms as often as their own threadbare garments.

In the left foreground the battery cook with his mess mule in tow distributes coffee and salt pork to a group of soldiers. Another group, to the middle right, uses a drum for a table in 'bluff', the Yankee soldier's favorite game of chance.

The breastworks are typical of the temporary fortifications peculiar to our Civil War. Dirt was piled in front of a log wall and sharp sticks stuck in the dirt to repel a possible bayonet charge. The two field guns trained on the road are Napoleons, smooth-bore brass cannon which fired a twelve-pound projectile. Loaded with canister or grape shot, they provided a deadly defense against troop concentrations at short range.

The two pickets in the distance would warn of the approaching enemy and then drop back quickly so that the road block would surprise the Confederates as they came out of the woods.

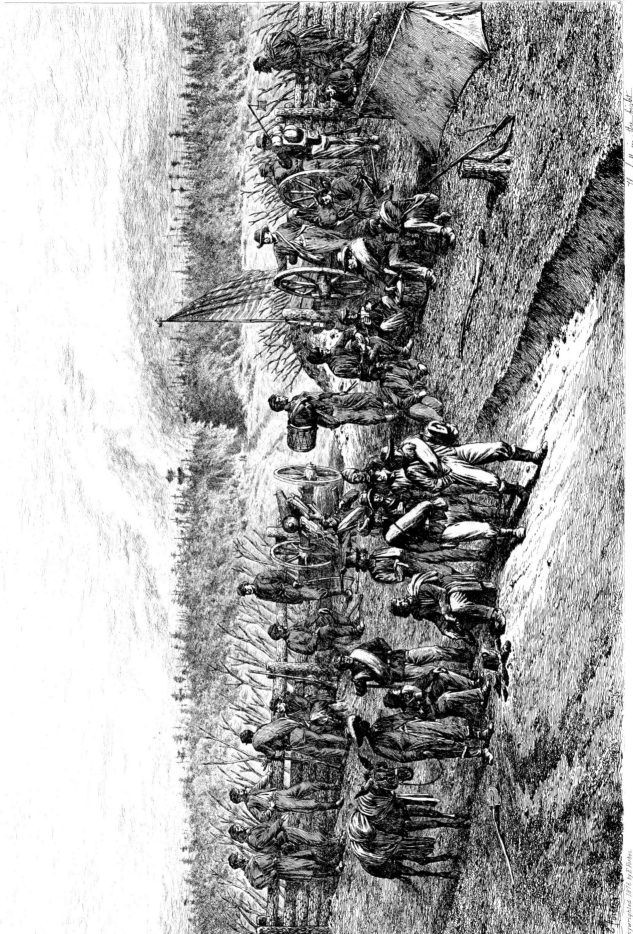

The lull in the fight

20

TRAFFIC BETWEEN THE LINES

During the winter of 1862 and 1863 communication between Yankee and Rebel pickets was friendly. Confederates would cut a shingle boat, rig it with a paper sail, and freight a hank of leaf tobacco over to the Yanks with a note requesting a return ration of sugar or 'real' coffee. Sometimes the gray coats would name their boat *Virginia*, which was the Southern name for the ironclad *Merrimac*. It would go back marked *Monitor*.

The exchange Forbes pictures here took place during the siege of Petersburg in the summer of 1864 when the fortifications were only a few hundred yards apart. There was such a shortage of newsprint in the South that many papers had to suspend publication; some were printed on the back of wallpaper.

'Yanks, hev you'uns got any newspapers?' Forbes heard a gray picket yell out during a truce. 'Cause if yer hev, I will give terbaccer for 'em and if you'uns has got coffee we'uns would like to get some.' 'All right, Johnny,' came the reply, and several pickets, leaving their guns behind, advanced into no man's land. The standing 'Reb' has leaf tobacco in his hand, while the blue coats measure out the coffee they will trade along with the newspaper that they pour it on.

In the distance are the Confederate earthworks complete with cannon emplacements and protected by abattis and chevaux-de-frise. This is the opposite view of a breastworks slightly more permanent and formal than the one displayed in the preceding sketch of a Union fortification.

Trading for coffee and tobacco. Between the forbidden lines during a truce.

21

'THE RELIABLE CONTRABAND'

In this drawing, a cavalry officer questions a 'reliable contra-band' while a vidette watches the wooded road in the distance against surprise attack. Considered personal property by the 'Secesh' slave owners, slaves were classed as contraband by the Yankee soldiers. This ingenious reasoning is attributed to General Benjamin F. Butler, who asserted early in the war that escaped slaves, being capable of rendering aid and com-fort to the enemy if returned to Rebel lines, were 'contraband of war.' Union forces should, therefore, receive and make use of these slaves. Although this position ran contrary to the fugitive slave law which was still in effect at the time, it fol-lowed the principle that human beings should not be owned by other human beings. Lincoln's Emancipation Proclama-tion, a document carefully worded to include only the slaves who were enemy property, finally resolved this emotional issue. The phrase 'reliable contraband' stuck and became war-time slang for all ex-slaves. The expression was widely used, sometimes seriously, but more often in jest, because as a source of information the escaped slave was willing, but most unreliable.

At advanced picket outposts cavalry horses were left saddled and bridled for hours, ready for the moment they were needed. Although a farmhouse was sometimes available, horses and troopers more often had no shelter. And when the enemy was near, fires were not permitted. Most troopers made their own rules in the presence of rainy, freezing weather and/or stolen chicken.

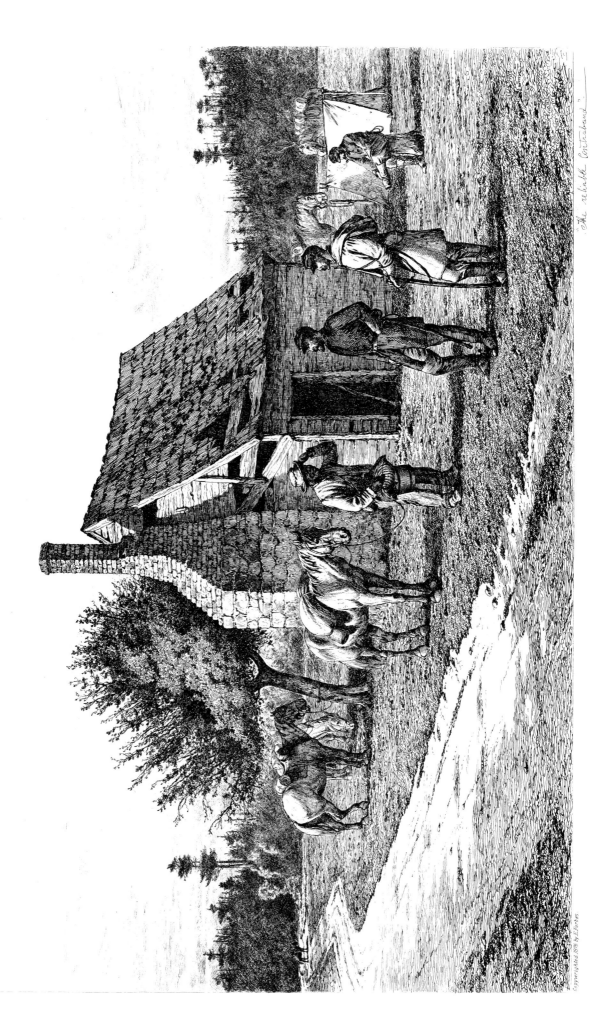

Copyrighted 1876 by E.Forbes

"The reliable Contraband"

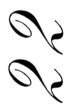

22

SOLDIERS PASS THE TIME

A Hot Day. A Federal gun crew loafs during a hot training exercise. The cannon is a smooth-bore Napoleon, cast in bronze. The various state militia used hundreds of different cannon, rifles, and pistols. The resulting variety in size, caliber, and type made it almost impossible to keep the soldiers supplied with any standard ammunition. Scandals arose because of the profits made in selling inferior ordnance to the Government. Even honest sales brought problems: no single rifle or cannon could definitely be established as best for any given purpose; and even if it had been, private armories would have preferred to make their own models.

Beef Steak Rare! Most men old enough to grow a good beard preferred chin whiskers to the dangers of the company barber. The independent 'wagoners' in their broad-brimmed hats were no exception. The wagoner Forbes shows here also illustrates the way the government-issue uniform could be worn. The blue-gray trousers were too long, too heavy, and too loose at the ankles, and when they were not tucked in the socks, they dragged at heel and collected mud, which made marching more difficult than usual.

A Straggler. Forbes pictures a veteran of six battles. This soldier is identified by the infantry horn on his forage cap and the brass initials 'U.S.' on his cartridge box. Otherwise he is like any middle-aged private in any army, too old and too wise to want any part of a foot soldier's war. Slung over the veteran's musket barrel is his belt, bayonet, and cartridge box. He has thrown away all but these bare essentials.

A Quiet Nibble on the Cavalry Skirmish Line. While a cavalry trooper watches the horizon and a fellow trooper on the skirmish line, his horse nibbles the dry grass. The horse might have come from western contractors who shipped railway car lots east for the army. Volunteers often brought their own mounts with them, receiving due compensation from the Army.

The cavalryman was armed with saber, revolver, and a single-shot carbine, which was shorter and lighter than the infantry rifle. Cartridge box, canteen, tin cup, shelter tent, and blanket roll formed the rest of his equipment, with curry comb, nose bag of corn, and a single rein curb bit.

A Cavalry Orderly Awaiting Orders. A corporal holds his officer's mount. The horse's saddle is one of the kind that General McClellan recommended to the Army and was still in use when the cavalry gave up its horses in World War II. The pistol the cavalrymen used was the Colt's revolver, loaded with ball and powder and fired with percussion caps. The long, straight Prussian saber was soon replaced with a lightweight curved saber.

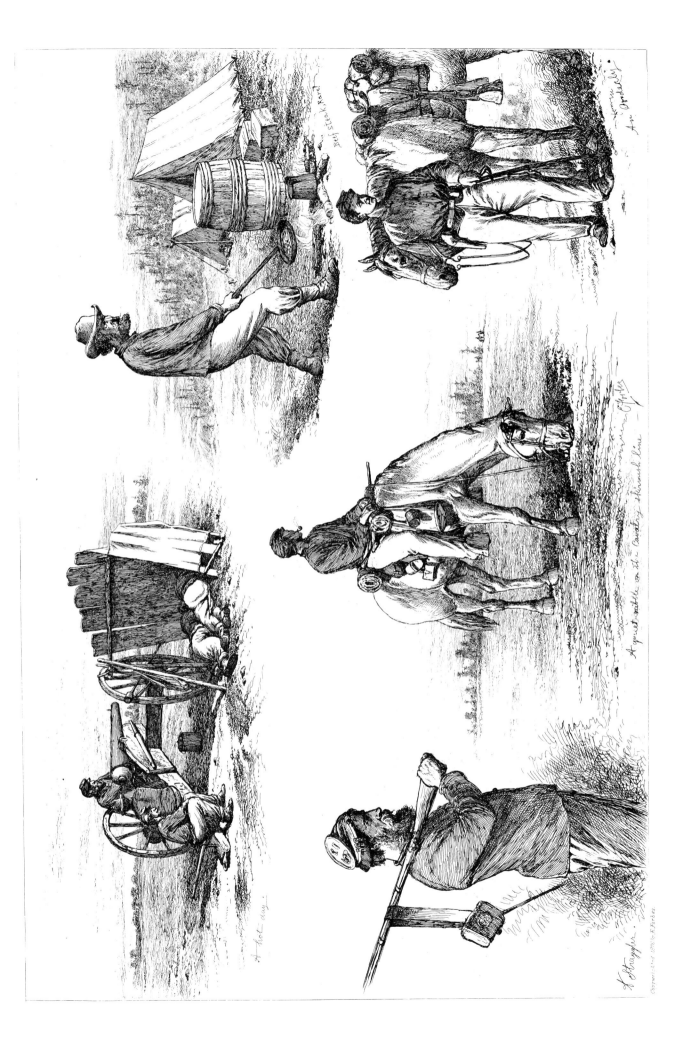

23

NEWSPAPERS IN CAMP

Soldiers in the Civil War as in any war led a sheltered life as far as knowing what went on anywhere else but in their own section of the front. 'Hurry up and wait, hurry up and wait' was the pattern of their life. During the waiting periods they devoured any news they could get and listened to rumors if they could not get news any other way.

In this Union Army scene, a newsman unrolls his single-sheet newspapers while the boys in blue buy and read 'the latest news from the front' fresh from the rear. The pine-bough beds and home-made stools indicate that the troops were in a semi-permanent summer encampment. The pup tents of World Wars I and II were almost identical to the shelter tents of the Civil War. Judging from the leggings on three soldiers, this scene was drawn early in the war. Leggings gradually disappeared in Civil War combat as they did in World War II.

24

THE REAR OF THE COLUMN

No army could move without wagon trains, their own or someone else's. 'The Old Wagon Hunter,' Stonewall Jackson preferred to drag few of his own and to live off the slow trains at the tail end of whatever Union army he was chasing. The gray-coated horsemen of J. E. B. Stuart, John Singleton Mosby, Turner Ashby, and Nathan Bedford Forrest were present in the nightmares of every Union wagon chief. Stuart actually rode all the way around the Army of the Potomac on two occasions, but Forrest and Mosby raided the wagon trains more frequently. 'Bushwhacker' Mosby's rangers exhausted the life blood of quartermaster and commissary trains all over Virginia. Finally, the pattern later used by allied ship convoys in World War II was adopted. Well-guarded, the trains took zig-zag courses over country roads, moving in small groups rather than stretching out in a long vulnerable line. If a surprise was feared, the guards took position off on the flanks and watched critical crossroads where the enemy's cavalry dash most often occurred.

On one such occasion in 1863, Union forces crossed the Rapidan River and, followed by their wagon trains, were advancing on the Confederate lines. The 5th Corps train between Wilderness Tavern and Mine Run had to make a sharp turn onto the Orange Court House Road. At this point the Confederate cavalry dashed up and detoured the first wagon toward Chancellorsville. The other wagons followed. A squadron of cavalry remained behind to prevent a rescue by train guards. The Union 5th Corps was left with no supplies.

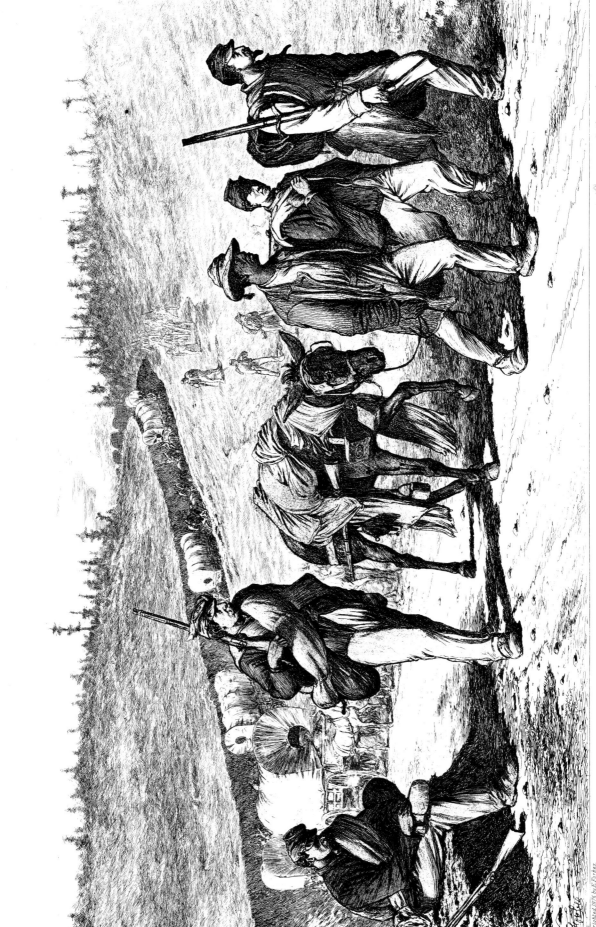

The rear of the column

25

ON THE MARCH

Fording a River. As a fourteen-year-old fifer observed in his diary, 'Fording a river is no fun, and Virginia had forty fords to every bridge. We had to wade these rivers often in the midst of a long march. Marching is difficult in dry clothes. With our heavy woolens dripping and our shoes soaked it is awful.' Forbes drew a crossing much like the one that the boy described.

Experienced infantrymen learned that the trouble of stripping, at least from the waist down, and redressing on the opposite shore was well worth while. Here one smart 'walking-soldier' has bummed a ride on the rumble seat of the company cook's mule. Another regiment has made the crossing and is shown marching off on the far left. The unmanned breastworks dug into the river bank (near the center) were strategically placed to prevent such a crossing.

The water, though shallow enough for wading, was often swift, and cavalry horses were stationed downstream in order to catch infantrymen swept off their feet by the current. Sometimes in swifter water a rope was strung across to give the troops something to hang on to, but this did not always work. Many Union soldiers died by drowning during the war.

Twenty Minutes Halt. It was Stonewall Jackson and his Confederate 'walkin' cavalry' who developed the ten-minute break still used on long marches. He found that his men could march better if they looked forward to a regular stop every fifty minutes.

The Union armies had no regular rest period. The average speed on fair roads was three miles an hour provided that a heavy wagon did not get stuck in a bog up ahead. After four or five hours of continuous marching, the command 'Halt' would be given. Immediately the troops dropped beside the road and, using their haversacks for pillows, fell asleep in an instant. 'Many times,' Forbes said, 'I have ridden along the road where 10,000 men who had been briefly halted were lying as if dead. Dust-covered and powder-stained, and with the hot sun beating upon their faces, they lay stretched upon the ground oblivious of surroundings or conditions.'

'You hope,' said a Massachusetts drummer boy in a letter home, 'that the halt is for a rest and you throw yourself on the ground. But it may only be somebody double-hitching a wagon up ahead. The instant you have stretched out your legs the column may start forward again, and you must climb to your feet more exhausted than ever.'

26

AN ADVANCE OF THE CAVALRY SKIRMISH LINE

Forbes never missed a chance to draw horses. His subjects rarely looked like this after the first engagement, although the exaggerated step of the left front foot may indicate 'hoof-rot,' 'grease-heel,' 'scratches,' or one of the other hoof diseases which plagued the horses of the Potomac army. The leather halyard was used to pull the horse down to the cover of the ground if horse and rider ran into an infantry ambush. These horsemen were the advance guard for the main body of cavalry massed in the rear.

Originally, cavalrymen were thought of as mounted infantry who dismounted when the fighting began; soon they were dismounted most of the time. At the outbreak of hostilities there were more than 4,500,000 horses and 450,000 mules in the local states and territories, yet before the war was over Washington had to buy horses from Canada.

One regimental commander's eloquent appeal for remounts brought this reply from the quartermaster: 'I'll tell you frankly, Colonel, that we haven't five pounds of horse for each man to be mounted.' 'That won't help much,' the commander replied. 'We were thinking of riding the brutes, not eating them.'

Toward the end of the second year of the war, a 2650 horse hospital was established at the Giesboro Cavalry Depot in Washington. Some 170,650 cavalry mounts and 12,000 artillery horses went through this giant hospital, clearing-house, and rehabilitation center. Horses that did not recover to Army specifications were auctioned at thirty dollars a head, but most could be returned to the field.

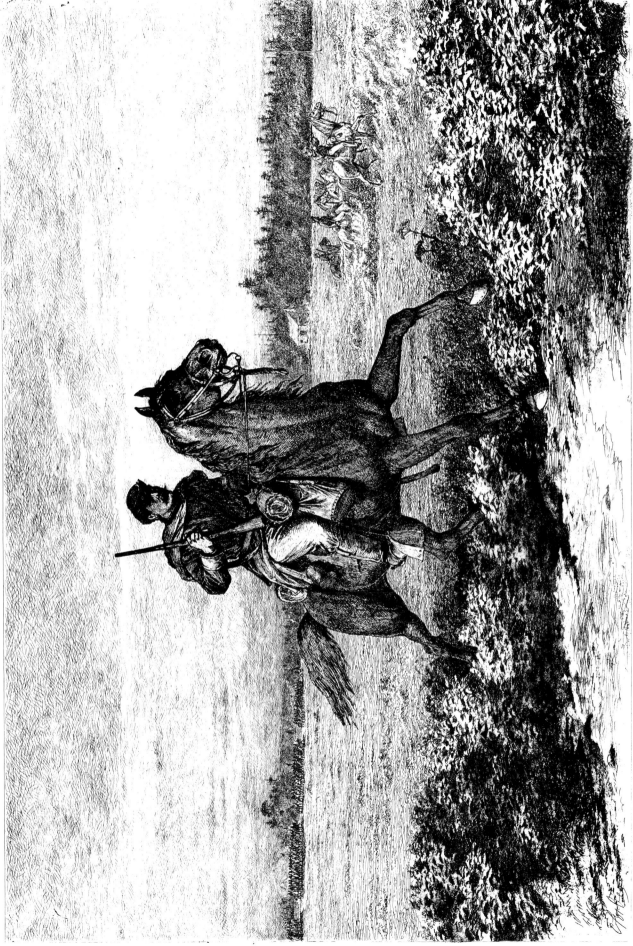

The advance of the Cavalry skirmish line.

27

AN ARMY FORGE

Two cavalrymen returning from a long scouting mission stop at the blacksmith shop to have their horses shod. At first each Union cavalry trooper had carried his own shoeing equipment along with another extra hundred pounds that had to be shed if the Federal armies were to have any horses left. The portable forge was a part of every cavalry squadron's equipment. Many of the army-trained blacksmiths became experts at repairing guns and treating hoof diseases as well as at fixing wagons and shoeing horses.

Most of the conversation as Forbes penciled this sketch was about the trooper's little dog Mike, who was a self-styled scout for the cavalry scouts. Mike loved the rattle and crash of musket and cannon and his hobby was chasing half-spent shot as a kitten frolics with a ball of yarn. Mike was twice wounded and lost the tip of his tail in the cavalry charge at Kelly's Ford.

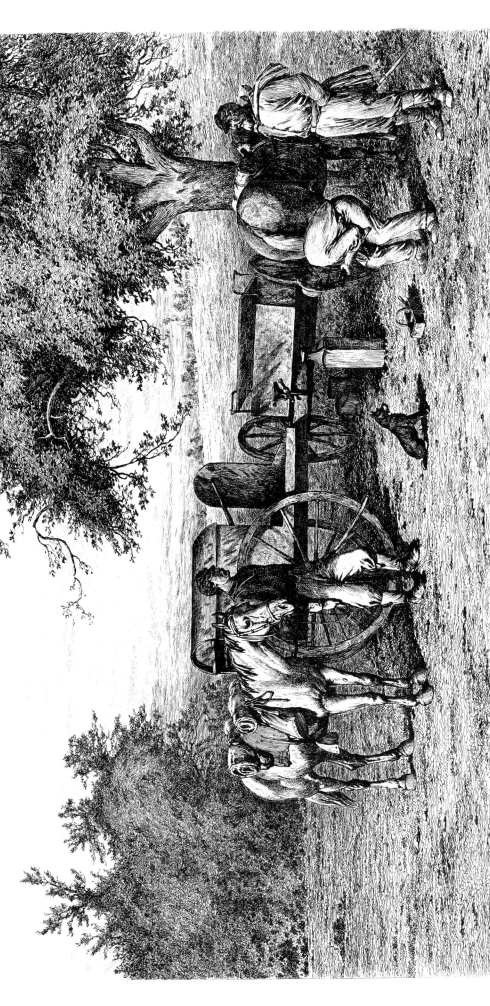

An Army Forge.

28

A CAVALRY CHARGE

We can almost hear the bugle sounding and the sabers slashing in this picture of a cavalry charge. The Union objective was the Confederate gun battery that was rushing up the hill to the rear. Rebel infantry and cavalry were trying to hold the line until their howitzers and rifles got away.

The battle took place on June 9, 1863, at Brandy Station, or Beverly Ford, on the Rappahannock. The Union cavalry had planned a reconnaissance in force of Confederate troops on the Culpeper-Fredericksburg Road. By strange coincidence,

J. E. B. Stuart's cavalry had also planned to cross at Beverly Ford that morning in order to divert Union attention from Lee's northward dash into Maryland. Since the Rebels wanted to be seen and the Federals did not, the latter got moving first. They crossed the river at 4 a.m. under cover of heavy fog, ran into Stuart's surprised outposts, and nearly captured his artillery. There were heavy losses on both sides as the Confederates were pushed back to Fleetwood Ridge where they finally held and the Union forces had to withdraw.

On the Confederate side of the fierce battle pictured here, Stuart's biographer wrote: 'A part of the 1st New Jersey Cavalry came thundering down the narrow ridge, striking McGregor's and Hart's unsupported batteries in the flank, and riding through and between guns and caissons from right to left, but were met by a determined hand-to-hand contest from the cannoneers with pistols, sponge staffs, and whatever else came handy to fight with.'

This was the first great cavalry combat of the war, and it gave the much maligned Union cavalrymen confidence in themselves and in their leaders.

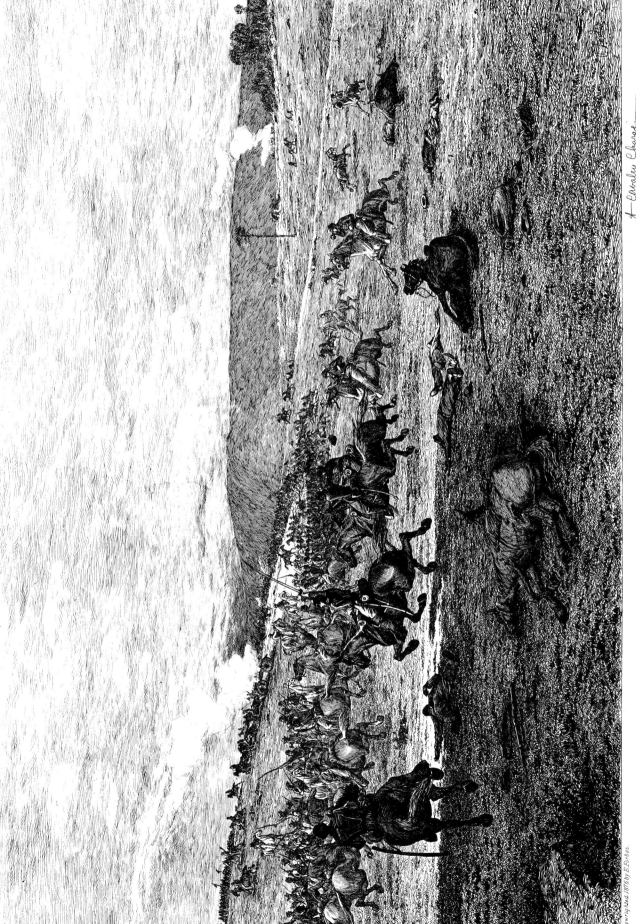

A Cavalry Charge.

29

THE DISTANT BATTLE

'I fully expected when I started for the front,' Forbes said, 'to accompany the troops into battle, sit myself on a convenient hillside and sketch exciting incidents at my leisure.' How greatly reality differed from imagination is suggested in this battle sketch. There was rarely a safe place close enough to see anything but smoke.

The troops marching on the left were two hours from the booming cannon. They could hear warnings of their future more distinctly with each step through the black of the early-morning valley. Close yet completely forgotten were the breastworks of yesterday's battle.

When the army was retreating instead of advancing, abandoned breastworks were not always so barren. They bristled with obstacles and were often heavily fortified with 'Quaker Gun' batteries. As Quakers are conscientious objectors to war so were the 'Quaker Guns,' wooden logs shaved and painted to look like cannon, and never to fire a shot.

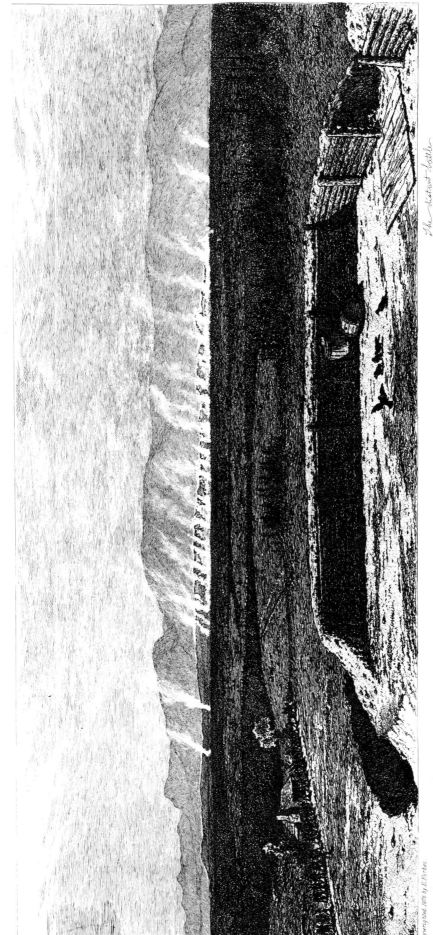

The distant battle

THROUGH THE WILDERNESS

There were few stone roads in the South over which to pull loaded caissons and 1200-pound cannon. Mud accounted for the deaths of more than four times as many horses as did battles.

Each gun crew carried, in addition to the personal effects of the artillery men and feed for the horses, loaded ammunition pouches, bag cartridges, priming box, elevating screw extractor, and long-handled sponge, rammer, and hand spikes. Three types of ammunition were used: solid shot, shell, and case.

Solid cannon balls or projectiles were used in all kinds of action. The hollow shells contained a bursting charge that exploded in the air or on impact, depending on whether it had a time or percussion fuse. Shells were used for long-distance firing, and case for close-range. There were two types of case ammunition: the canister, which sprayed a cylinder of deadly grape shot and was used against enemy personnel; and shrapnel, which separated at a distance due to a bursting charge.

Field guns were of two kinds: three-inch ordnance rifles and smooth-bore Napoleons. The rifles, like the one shown here, were made by wrapping boiler plate around an iron bar to form a rough cylinder, welding it together, and finally boring it out and shaping it. They were ten-pounders, accurate at medium distance because of the rifling inside its bore. The smooth-bore Napoleon was a twelve-pounder cast in solid bronze, then bored and prepared. It was to be preferred for short range in rough country. It had a wider mouth, carried heavier charges, and was more effective with canister. Later in the war, breech-loading Wiard steel guns and others were added. Although they proved more efficient, they complicated supply problems.

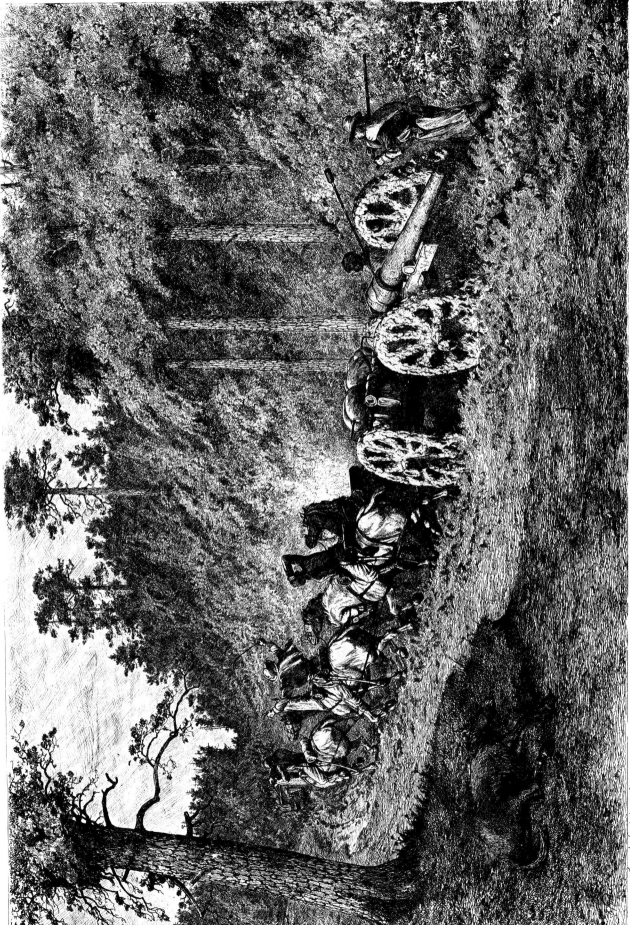

Through the Wilderness.

GOING INTO ACTION

Forbes pictures the artillery reserves going into action along Cemetery Ridge, with Culp's Hill in the background. It was this artillery which helped stop General George E. Pickett's charge at Gettysburg on the third day and turned the tide for the Union.

Before the charge both sides had engaged in one of the greatest concentrations of artillery fire of the entire war. Federal artillery had blazed for two hours; then all guns stopped while the ammunition supply was replenished. This deceived the Confederates, themselves low on artillery ammunition, and they made the famous charge. No sooner had they moved than the Federal guns belched forth all along the line, concentrating entirely on the approaching infantry. Pickett's Virginians, approximately 4800 strong, with some 10,000 supporting troops from Hill's Corps were cut down as they charged straight into the artillery canister. Both flanks were laced with withering small arms from sheltered Union infantry. About two-thirds of Pickett's gallant men were killed, wounded, or missing, and only one field officer of the division was not listed among the casualties.

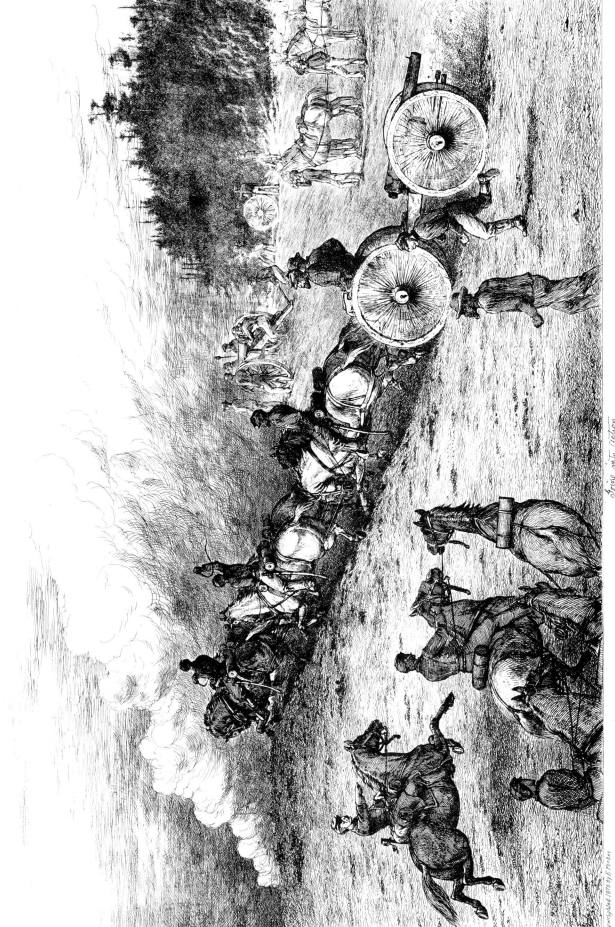

Going into Action

32

A NIGHT MARCH

During the Battle of the Wilderness, Forbes sketched this night march. In the dense black woods a turpentine pine tree had been fired to light up the march, but the blaze beyond in the underbrush was ignited by burning cartridges. The horror of battle was intensified by night, for the soldier could see no one. He listened breathlessly, and found relief in the first roll of musketry. As the firing increased, officers shouted commands and the men closed ranks, stumbling forward into the attack. Some were trampled to death by their own cavalry or the artillery horses, others were burned because they were too badly wounded to move away from the spreading brush fire. Great columns of smoke and flame rolled up in the woods, cutting the combatants apart.

Forbes recollected that on one occasion his heart almost stopped beating as the 'Rebel yell' went up from a rapidly advancing line in a chorus so tremendous as to drown out the roar of guns, but the sound died down before a rolling volley from the Union infantry. A battery of Napoleon guns opened on the advancing men with canister, and the crash of the terrible hail could be heard tearing through the trees. The enemy was soon repulsed, for there was no response to the battery, save intermittent musketry fire that looked like fireflies as it crackled among the trees.

Once the fight was over, officers and men dropped down on the ground, oblivious of all surroundings.

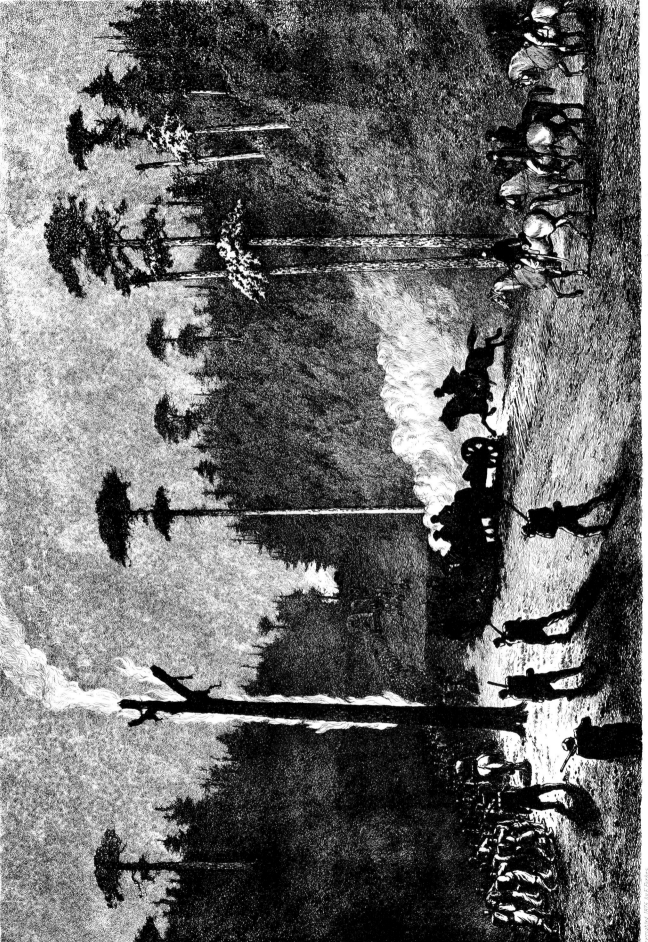

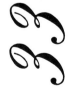

THE LEADER OF THE HERD

When the Army of the Potomac left Brandy Station in 1864 on its march to Petersburg, each soldier carried a six-day ration of hardtack, coffee, sugar, and salt. Supply trains carried a ten-day ration with enough salt pork for one day. All other meat was driven on the hoof. Beef to feed more than 100,000 men for thirteen days made a tremendous herd, and General George G. Meade insisted it go over separate roads in order not to impede the march.

The herder leading this group of steers is a butcher from the 38th Regiment, New York Zouaves, one of the few units to retain its uniforms until the end of its three-year enlistment.

Many professional butchers enlisted in the army and served in their former civilian capacity. Other meat cutters gained their slaughtering experience with the army. There is no evidence to show how each regimental commissary cut up the well-exercised steer and decided who got what, but it is certain that most became stew meat.

Along the road are Union graves from another battle, for this was the fourth time the Army had advanced through northern Virginia. Headboards for the graves were made from cracker boxes, and the simple markings on them bore basic identification only.

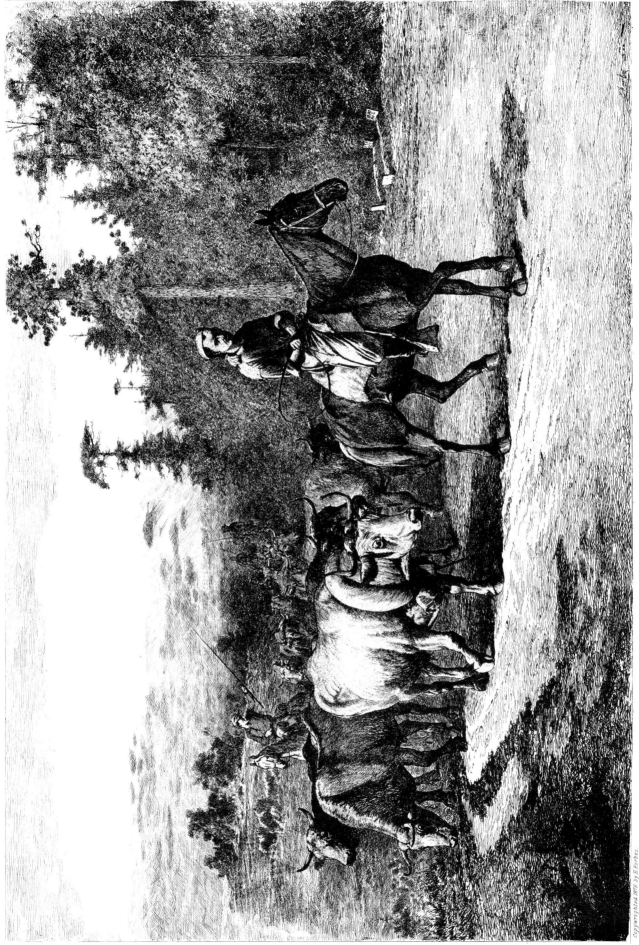

34

REPOSE ON THE BATTLE FIELD

A Watched Pot Never Boils. The Captain's Negro cook, like any good soldier, could sleep anywhere, whenever there was a minute to spare. Both Union and Confederate armies used the Negroes as labor troops, cooks, teamsters, grooms, and personal servants. The Union Army had more than 175,000 colored troops, over half of whom were contrabands 'recruited' in the South.

A Hasty Supper. After dark the tired soldiers sat around the fire and griped while their rations cooked. The soldier prepared his salt pork and hardtack by holding the meat on a forked stick over the flames so that the black fat would drip on the biscuit to soften and flavor it.

Drummer Boys. Each regiment brought its own band to war, but many musicians left when called upon to tend the wounded in battle. The drummer boys and fifers stayed on and were used in many ways. They aged rapidly in combat, but did not outgrow their zest for pranks or their ingenuity. One regimental colonel noticed a boy who was not beating his drum and demanded an explanation. The boy refused to answer and was called out of ranks. Whereupon he whispered, 'Colonel, you know that farm we passed on the march this morning—well, I've got two fat geese in the drum.'

'Of course, boy, if you're sick, you don't have to play,' the colonel shouted. That night the colonel's mess had roast goose. Some tents away the drummers and fifers had roast goose too.

Played Out. Marching barefoot was common practice with both Union and Confederate troops. The shoes in which the Federals reached the front after mobilization were deplorable; probably not one pair out of four could stand a ten-mile tramp. It took the 'Iron' Secretary of War, Edwin M. Stanton, to force civilian contractors to live up to the Government's shoe specifications. After that the shoes were sturdy and tough enough, but often poorly fitted at company level. Sand and gravel would work in when a soldier was marching in line, and he would have no chance to remove the source of irritation until the next long halt, perhaps hours later. Many men owned but one pair of socks at a time and wore them without washing as long as they held together.

"Scratching for more fuel."

"Playing drippers."

Played Out.

Drummer boys.

Copyrighted 1876 by E. Forbes.

35

NECESSARY ROUTINE

On Picket. Sentry duty was most important in the Union armies since they spent most of the war camped in enemy territory. Every combat soldier pulled a great deal of guard duty, but not always under the miserable conditions shown here. General Meade, for example, became greatly alarmed as Confederate spies and combat patrols seemed to cross through Union lines so easily. One night he went out to test his sentries and came upon a young recruit. 'Stop,' said the sentry, 'Have you the countersign?' 'No,' replied the general, standing in the shadows so as not to be recognized. 'What, another one without it?' exclaimed the recruit in disgust. 'Well, I'll tell you; it's Victory!' The quick-tempered Meade gasped for breath and then roared, 'What do you mean by giving anyone the countersign? I'm General Meade, and I'll have you hanged.' The sentry was amazed. 'Why, my orders were not to let anyone pass without a countersign, and let me tell you, I'm tired of giving it. Such a lot don't seem to know it.'

Washing Day. Any free moment when there was water and sunshine became a wash day. Washing had to be done hastily during short halts; time for drying was out of the question. Shirts, socks, and bandanas were tucked under a knapsack strap or attached to a musket where they fluttered and dried in the breeze as the soldier marched along. By the time they were dry they were brown with dust.

In camp or behind a breastworks the men could improvise washtubs from pork barrels and hang the clothes on tent ropes and on the limbs of trees. They were also expected to wash themselves twice a week. A private from the 41st Ohio related an experience at Murfreesboro when a party of about one hundred were washing at a spring. 'We had removed our clothes, placing them in kettles, built fires, and were boiling them out, when a party of Rebel cavalry came thundering down upon us in pursuit of a forage train that had been sent out in the morning. What were we to do? We had no arms with us; our clothes were in boiling hot water, the enemy were drawing near, fearfully near. Jumping over the fence, the whole party of us scud [sic] right through the town for camp. The citizens supposing we would all be captured, came out in great glee, shouting, 'Run, Yanks! Run!' We reached camp in safety, but it was a long time before we heard the last of that washing day.'

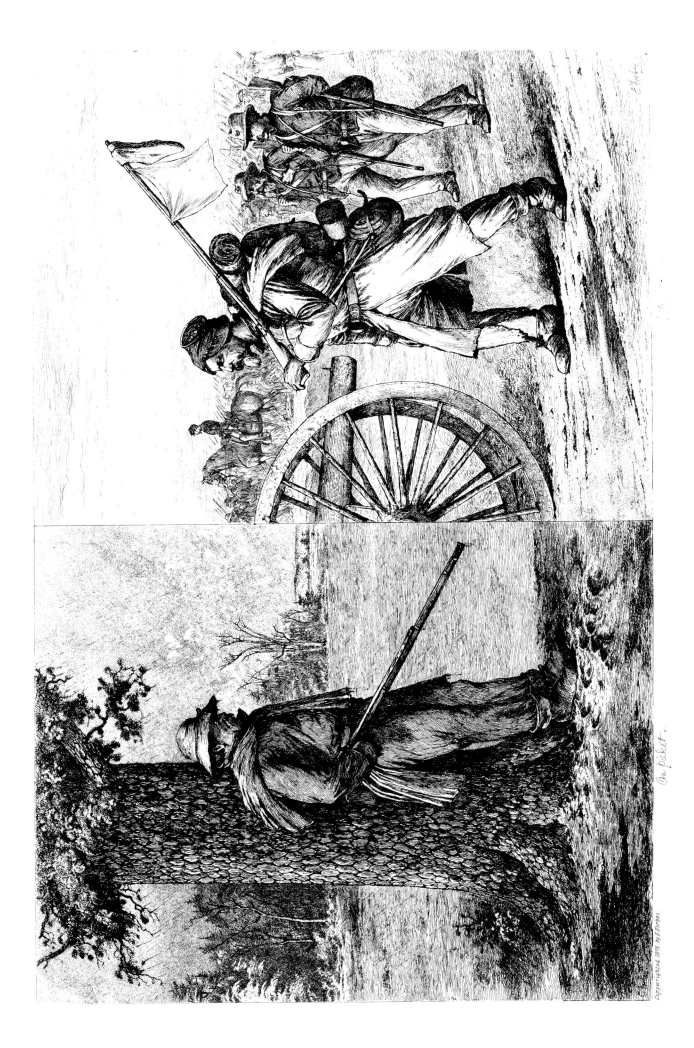

On picket.

THE NEWSPAPER CORRESPONDENT

War correspondents have always been portrayed in their newspapers as dashing heroes—men of courage dodging bullets and cleverly bringing out the story under fire—for it is good business for a paper to build up its correspondents. Forbes was a true member of the newspaper fraternity, and he never missed an opportunity to glamourize the profession, as witnessed by three drawings in this selection of sixty sketches.

As odd as they may look today, Forbes' galloping horses, like the one here, were much admired at the time he drew them. He first gained fame as an animal artist. His horse always had the exaggerated features popular in contemporary art: snorting nostrils and frantic eyes. After the war Forbes attained some prominence painting portraits of Union generals, each mounted on one of these circus-type horses.

It was not until 1877 that Eadweard Muybridge, a photographer working for Leland Stanford, took the series of magic-eye photographs that finally established the fact that a galloping horse does not have all four feet off the ground at the same time.

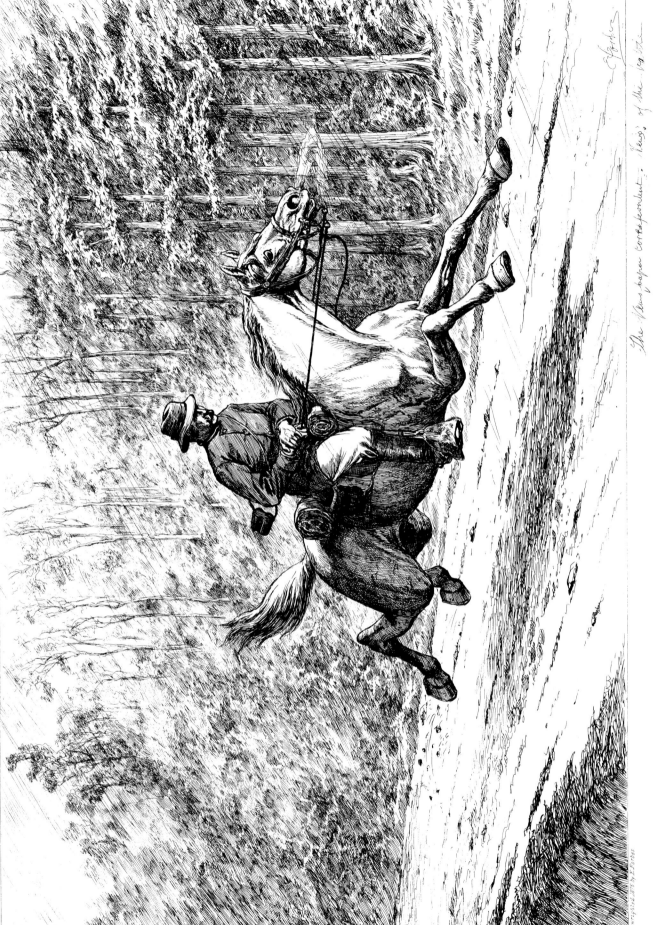

SCENES ABOUT THE COUNTRYSIDE

'Gone off with the Yankees.' This deserted one-room cabin was typical of the quarters which housed the slaves. This one was constructed with squared logs, jointed at the corners, although some were made of brick. All had peaked roofs, roughly shingled. The chimney was laid outside the house at one end and might be made of stone as shown here. More often it was built with sticks crossed at right angles and heavily plastered with clay. Some cabins had a triangular chimney which was formed by two angled walls of logs whose inner ends were fastened to the house. This construction yielded a very wide fireplace with a huge open hearth.

A Land Flowing with Milk and Honey. Troops in any war regard stealing food as fair sport. In an attempt at cartoon humor Forbes shows two city boys from a New York regiment trying to strip the land of its milk and honey. Anything foraged from civilian food stores was a change from the plain commissary ration and tasted good enough to risk being kicked or stung or even caught in the act. Apple orchards near the road were picked bare by marching troops, and Southern corn fields seemed to have been cursed with a locust plague. Poultry and rabbits all but disappeared, while truck gardens, berry and melon patches were plundered with devastating efficiency.

A Scouting Party. Most cavalry troopers welcomed scout duty as an exciting change from the dull routine of camp life. Although they were sometimes killed or captured, even the prospect of death or of imprisonment at Andersonville could not discourage them.

When sent out to destroy a bridge, to raid a wagon train, or to burn an ammunition depot, the parties were quite large, with advance guards thrown out to prevent an ambuscade. When the mission was to locate the enemy, to get information, to select the best route of march, or to ride flank and protect the main marching column from surprise, the party would be smaller.

An Old Campaigner. Each infantry company was entitled to one mule to carry supplies. This mule was generally entrusted to a contraband Negro. The Federals stole mules, when they had the chance, and conscripted slaves to handle them.

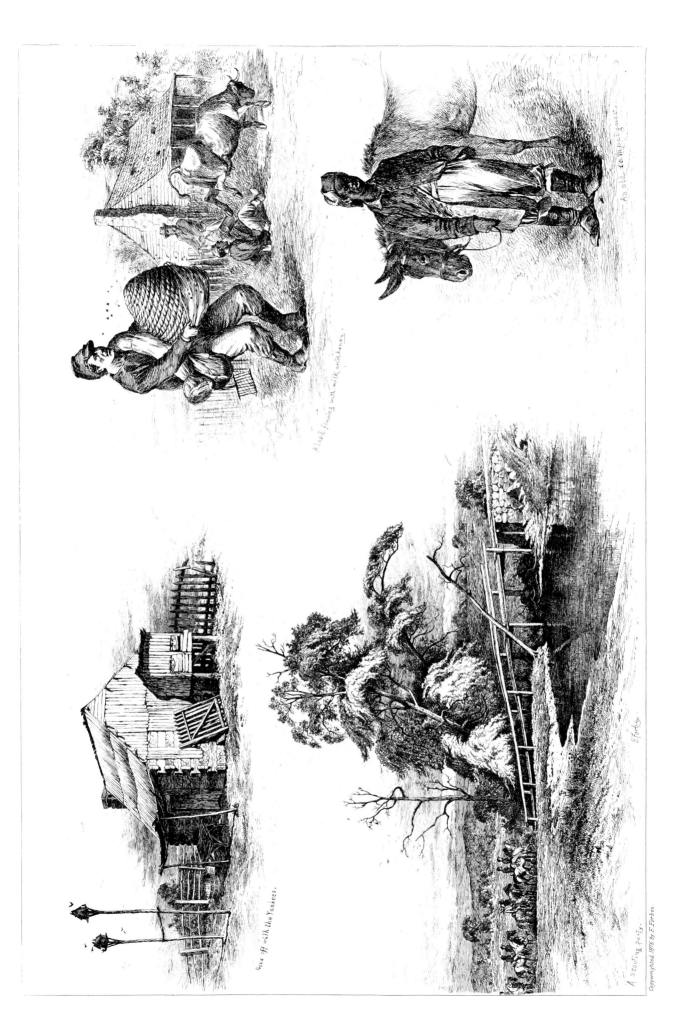

A boy flirting with milk and honey.

An old campaigner.

Gone off with the Yankees.

A scouting party.

E. Forbes.

Copyrighted 1876 by E. Forbes.

COMING INTO THE LINES

After Lincoln's Emancipation Proclamation on January 1, 1863, Negro refugees began streaming into the Union camps. Forbes was visiting a picket outpost near Culpeper Court House, Virginia, in the summer of 1863, when he sketched this family. The scene is early morning, for the slaves invariably had to sneak away from their plantations after dark and travel at night. Aside from the topless prairie schooner and assorted beasts of burden 'borrowed' from their former master, this family brought only their best clothes, never dreaming that the Yankees might put them to work. Another emancipated slave is seen waving to the 'Linkum sojer' as he trudges up the road in the distance.

The two outpost guards in the foreground, heating a pot of morning coffee, would question each incoming group of slaves as ordered. 'Where are you from?' they asked the old Negro. 'Culpeper Court House, Sar.' 'What's news down there?' 'Nothin' Massa, 'cept dar's a man down dar lost a might good and valuable nigger dis morning, and I reckon he dun lose more afore night.'

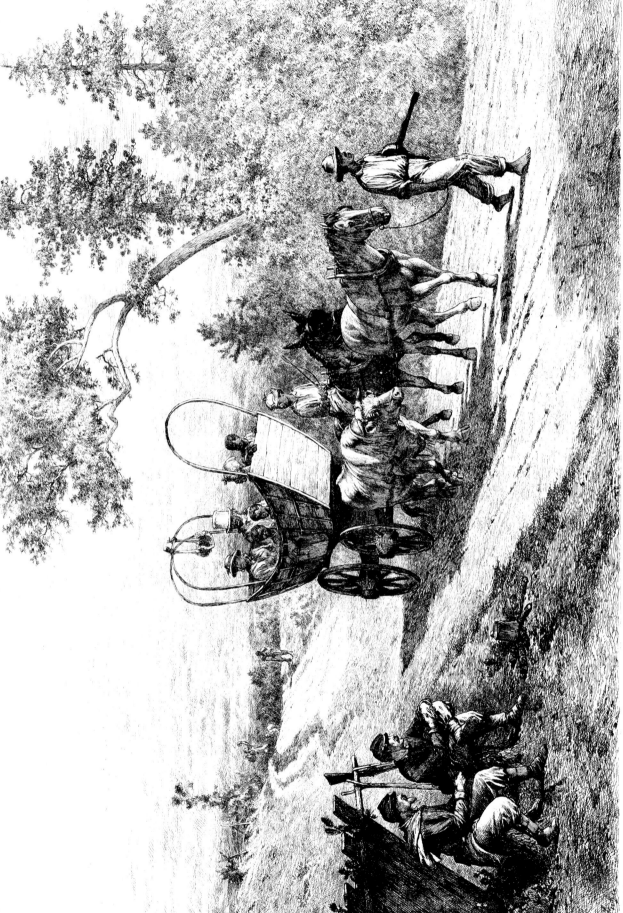

Coming with the horses

39

BUILDINGS AND PEOPLE

Dabney, the Orderly. According to folklore, General Joseph Hooker's best scout was an ex-slave named Dabney, whose advance knowledge of enemy movements confounded intelligence officers. 'I get the news from my wife,' Dabney confided at last. 'She washes for the officers and cooks and waits around, and as soon as she hears about any movement or anything going on, she comes down and moves the clothes on that line so I can understand in a minute. That there gray shirt is Longstreet; and when she takes it off, it means he's gone down about Richmond. That white shirt means Hill, and when she moves it up to the west end of the line, Hill's corps has moved upstream. That red one is Stonewall. He's down on the right now, and if he moves, she will move that red shirt.'

'Got any pies for sale, Aunty?' Yankee soldiers were forever scrounging for food to the familiar cry of 'any pies for sale, Aunty?' Fresh apple and blackberry pies could be purchased for a nickel, but the Negro women had little use for money and preferred coffee, salt, or sugar in exchange. If a soldier did not get pie, he could count on hot corn bread and sorghum or cookies.

A Pickaninny. Unceasing streams of slaves sought the protection of the Union lines, wrote Forbes. 'The mature and strong carried the helpless pickaninnies, who with round wondering eyes were at a loss to understand the change; the elder children would trudge along clinging to their mother's dress; the old folks would sometimes be in carts or wagons, and sometimes hobbling along on foot; but all making as much speed as possible toward safety.'

A Slave Cabin. Overgrown with honeysuckle or trumpet vines, the cabins in the slave quarters stood long after the enemy army had passed through the plantation. Inside, they were usually divided into two rooms, although some had but one, which served for sleeping, cooking, and eating. The furniture was crude and scanty, consisting of one or two benches, an old armchair, and a bed.

The Old Grist Mill. In this old grist mill, corn meal and hominy grits were ground. With the large, narrow wheel little water pressure was needed to turn the grinding stones inside the mill. These overshot water wheels were once common in the South. The water came in at the top through an over-fall wooden sluice and filled the wooden troughs on the wheel just fast enough for the downward weight to keep the wheel rolling smoothly.

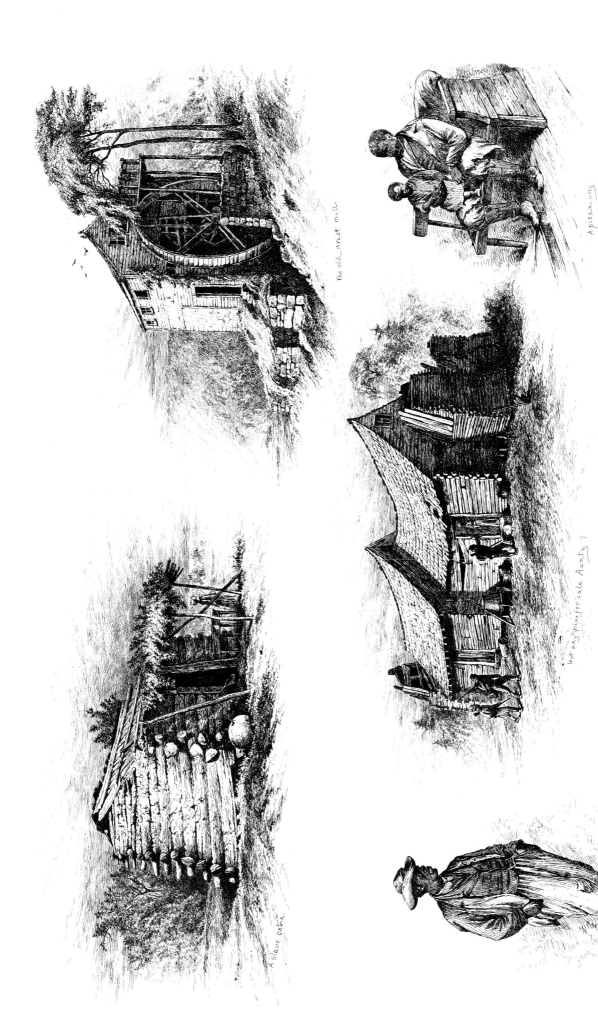

The old grist mill.

A gleaning.

Botany pins for sale. Aunts S.

A slave cabin.

40

THE SANCTUARY

In his volume of reminiscences, *Thirty Years After,* Forbes wrote rather sentimentally of the family group he had drawn. 'The old mother dropped on her knees and with upraised hands cried "Bress de Lord," while the father, too much affected to speak, stood reverently with uncovered head . . . It impressed me deeply with what the Federal success meant.'

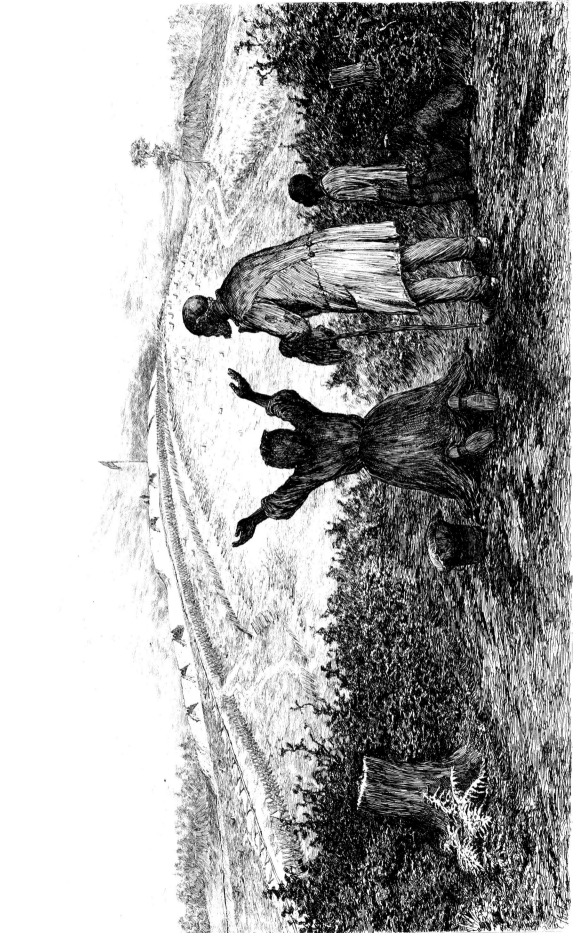

The Smokers.